Developing Professional iPhone Photography

Using Photoshop, Lightroom, and other iOS and Desktop Apps to Create and Edit Photos

Rafiq Elmansy

Apress®

Developing Professional iPhone Photography: Using Photoshop, Lightroom, and other iOS and Desktop Apps to Create and Edit Photos

Rafiq Elmansy
Newcastle Upon Tyne, United Kingdom

ISBN-13 (pbk): 978-1-4842-3185-2 ISBN-13 (electronic): 978-1-4842-3186-9
https://doi.org/10.1007/978-1-4842-3186-9

Library of Congress Control Number: 2017963387

Copyright © 2018 by Rafiq Elmansy

Cover image designed by Freepik.

Managing Director: Welmoed Spahr
Editorial Director: Todd Green
Acquisitions Editor: Aaron Black
Development Editor: James Markham
Coordinating Editor: Jessica Vakili
Copy Editor: Kim Wimpsett
Compositor: SPi Global
Indexer: SPi Global
Artist: SPi Global

Distributed to the book trade worldwide by Springer Science+Business Media New York, 233 Spring Street, 6th Floor, New York, NY 10013. Phone 1-800-SPRINGER, fax (201) 348-4505, e-mail orders-ny@springer-sbm.com, or visit www.springeronline.com. Apress Media, LLC is a California LLC and the sole member (owner) is Springer Science + Business Media Finance Inc (SSBM Finance Inc). SSBM Finance Inc is a **Delaware** corporation.

For information on translations, please e-mail rights@apress.com, or visit www.apress.com/rights-permissions.

Apress titles may be purchased in bulk for academic, corporate, or promotional use. eBook versions and licenses are also available for most titles. For more information, reference our Print and eBook Bulk Sales web page at www.apress.com/bulk-sales.

Any source code or other supplementary material referenced by the author in this book is available to readers on GitHub via the book's product page, located at www.apress.com/978-1-4842-3185-2. For more detailed information, please visit www.apress.com/source-code.

Printed on acid-free paper

Table of Contents

About the Author

Rafiq Elmansy is a design consultant, educator, and author. He is a design lecturer at the American University in Cairo and Adobe education partner with more than 17 years of experience in the design industry with clients around the globe. He teaches digital design, interactive design, and design management for both academic and industrial institutions including the American University in Cairo, Hawaii University, and Academy Class UK. Rafiq is an Adobe Certified Instructor, Adobe Education Leader, and Adobe Certified Expert. He works closely with Adobe teams in developing new products as part of the prerelease program and is an official writer for Adobe Certified Expert (ACE) and Adobe Certified Associate (ACA) exams.

Elmansy has been published by various publishers including Taylor and Francis, Focal Press, O'Reilly Media, and John Wiley & Sons. His published books include *Teach Yourself Visually SEO*, *Illustrator Foundations*, *Photoshop 3D for Animators*, and *Quick Guide to Flash Catalyst*. He has been published in both academic and industrial magazines and journals including the Design Management Review, Adobe Inspire, Smashing, and TutsPlus. He is also a jury board member in acknowledged design competitions including the Adobe Design Achievement Awards, Poster for Tomorrow, and A'Design Awards and Competitions.

Introduction

The idea of this book started when I was traveling without my camera and wanted to take photos in Paris. So, I just grabbed my iPhone and started taking shots of the amazing sightseeing there. That's when I discovered that the iPhone is a powerful photography tool with a high-quality camera lens, stabilization capabilities, and small form factor. The numerous photography and photo-editing apps on the App Store make it even more powerful.

Therefore, this book aims to help both professional and nonprofessional photographers start using their iPhones as a photography tool. It contains dozens of tips that start by helping you understand the core photography features on your iPhone and how to get the most out of them. Then, it moves on to tips that will help you use your iPhone to create photography projects that you used to create using your DSLR camera. These tips cover basic photo-editing skills such as adjusting colors, fixing issues, and replacing the background.

The tips then cover more photography techniques such as creating double-exposure effects, low-light photos, and high-key photos. These tips simulate the techniques that can be done using the existing light in the scene of the shot. The later chapters give you more photo-editing tips, such as creating a composition of different photos, manipulating photos to create dramatic scenes, creating digital artwork, and more.

During these tips, you will explore how to use a number of apps that can help you extend your iPhone's photography capabilities. This includes the Adobe mobile apps for Adobe Photoshop and Lightroom that simulate the desktop-based photo-editing versions. Most of the other apps in the book can be easily grabbed from the Apple App Store. Some are free, and others include trial versions to try before buying.

Later in the book, the tips explore how to organize your work on your iPhone and how to handle the space issues using the different cloud technologies including iCloud. Then you will explore how to start your work on your iPhone and then take it back to your computer to add even more effects to the shot.

All the photos in this book were taken with an iPhone by my wife, Radwa Khalil, and me in different countries. The only photo that was not taken by an iPhone device is the Earth photo that was grabbed from Wikipedia under the public domain copyright.

How to Use This Book

Each chapter in this book includes a number of tips that cover skills related to mastering iPhone photography. Each tip stands alone, so you can start the book with any of these tips and try them individually. If you are a newbie at using your iPhone as a photography tool, you can start with the first tip and move forward from there. If you have some knowledge, reviewing the first tips will help you to organize your photos and find hidden features on your iPhone.

Each tip gives an example of the workflow to create a specific effect. So, you need to read each tip and follow its steps and then try to apply it using your own photos. You may need to explore different values and options to create the most effective output with your own photographs. At the end of each chapter, there is a practice task that you can use to apply the effects used in the chapter to a photo and share it on different social networks; just use the hashtag #iPhonePhotography or mention me (@rafiqelmansy) on Facebook, Twitter, or LinkedIn. I will be checking your work and commenting on it.

Practice, Practice, and Practice

The more you practice with your iPhone, the more you will improve your skills. This book will start you on your journey, but further practice is important. Use the steps and figures to guide you to create effects based on each tip. Once you feel confident with these tips, you can move forward and explore other effects and techniques using the different photo apps available on the App Store to create even more fantastic iPhone photography projects.

CHAPTER 1

Unleash Your iPhone Camera's Capabilities

While the camera doesn't make the photographer, a good camera can definitely take your creative shots to another dimension and extend your ability to apply different techniques, especially with the evolving technologies related to digital photography cameras. The same rule applies to phone photography. The excellent camera in your iPhone allows you to take photos for both professional and personal purposes without the need to hold heavy photography gear. The Apple iPhone's camera is one of the features that sets the phone above the competitors.

To get the most of your iPhone camera, it is crucial to understand the camera's capabilities and the different features that can help you take good photos using both the default and third-party photography apps. In this chapter, you'll explore the capabilities of the default camera and the Photos app before moving on to different photography techniques in the remaining chapters.

Mastering Your iPhone Camera

Your iPhone camera has hidden features that can help you open the Camera app quickly. You can also improve your photo's composition by applying a grid system to align your scene.

1

© Rafiq Elmansy 2018
R. Elmansy, *Developing Professional iPhone Photography*, https://doi.org/10.1007/978-1-4842-3186-9_1

Get Easy Access to Your Camera

One of the iPhone's advantages is the ability to quickly take photos anywhere and anytime. All you need to do is grab the phone out of your pocket or bag, open the Camera application, and take the shot. However, you need to know how to quickly access the Camera app in order to catch those special moments, such as your kids playing or your favorite team winning the game. The iPhone gives you three main ways to access the Camera app quickly.

Swipe to Open

The first method is to swipe through your screen. This allows you to open the Camera app while the phone is locked, which is considered the quickest way to access the camera. Follow these steps:

1. If your iPhone is asleep, press the home button once to open the display.

2. While you are on the lock screen, swipe from the right side of the screen toward the left side to open the Camera app, as shown in Figure 1-1.

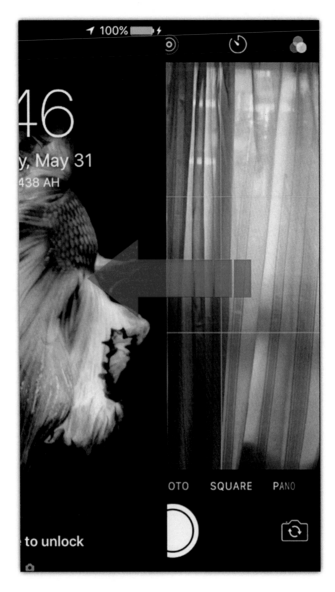

Figure 1-1. *Swipe from the right side of the screen toward the left side to open the Camera app*

Use the Phone Control Center

The second method can be used while the phone is locked or unlocked; you just go through the phone's Control Center.

1. If your iPhone is asleep, press the home button once to open the display.

2. Swipe with your figure from the home button toward the top of your phone, as shown in Figure 1-2.

3. Tap the Camera app in the Control Center.

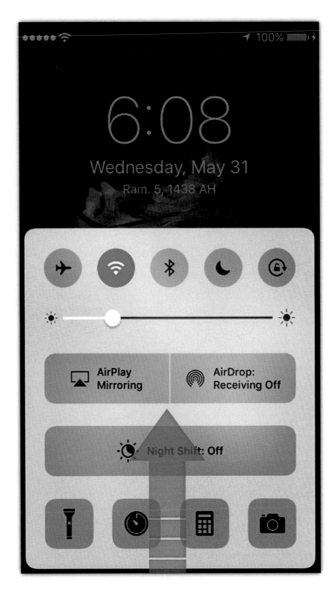

Figure 1-2. *Swipe from the bottom of the screen toward the top to open the Control Center*

These two methods are helpful when you need to easily access the camera when the phone is locked, while the next method allows you to access the camera quickly while you are using other applications on the phone.

Add the Camera App to the Dock

The third method is to add the Camera app to the dock of your phone. This helps you easily find the camera among the other applications installed on your mobile device. You can add the camera to the dock as follows:

1. Press your phone's home button twice to access the main screen (use a fingerprint or passcode if needed).

2. Tap and hold slightly on the Camera app icon; you will see it vibrate to indicate it can be repositioned, as shown in Figure 1-3.

3. Drag it to the screen dock next to your most used applications such as the Mail app and the Safari browser. If the dock is full, you can add it by removing the least used application from the dock.

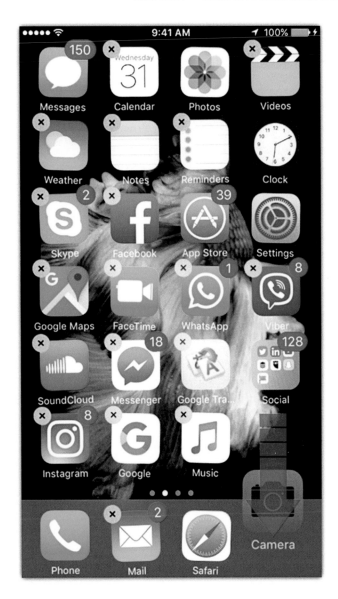

Figure 1-3. *Drag the Camera app to the screen dock*

Take Your Shot in Multiple Ways

The iPhone helps you to take your photo through three different methods based on different situations. The default method is to tap the camera button once to take the shot, as highlighted in Figure 1-4.

You can also press the volume button up or down to take the shot, also shown in Figure 1-4. This option helps you to hold your phone properly while taking the shot. It works similarly to the shutter button on your digital camera if your phone is in landscape position. Finally, if you are using a wired headset, you can use the volume buttons on your headset to take your shot. This helps you to take photos stealthily. For example, you can capture natural moments of your children playing without them noticing to produce spontaneous photos. Using the headset buttons can help you avoid shaking the phone while taking the picture.

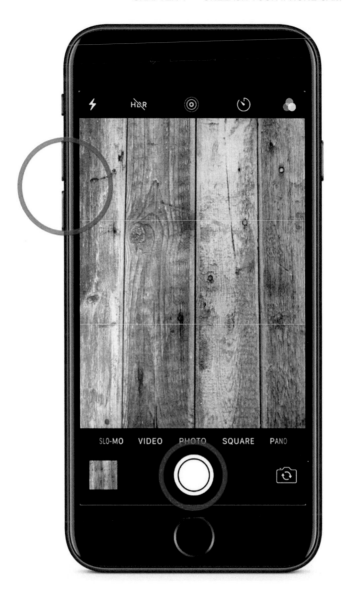

Figure 1-4. *Tap the camera button or press the volume button to take photos*

Enable the Grid Guides

As you probably know, the composition of a photo plays an essential role in making a great shot. The Camera app provides grids that can guide you while taking your shot to ensure that the composition is visually appealing. The Grid option divides the screen into three columns and three rows. This can help you to place the elements exactly where you want them in the photo. Follow these steps to enable the Grid feature:

1. Tap the Settings icon on your phone.

2. Scroll down and tap Photo & Camera.

3. Activate the Grid feature in the Camera section, as shown in Figure 1-5.

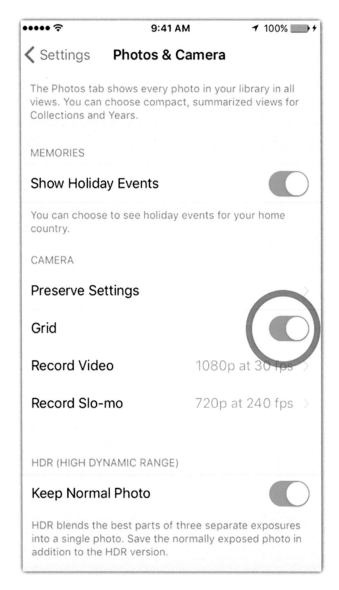

Figure 1-5. Activate the Grid setting from the Photos & Camera settings

Shoot in Burst Mode

For fast-moving events such as sports or children playing, you may need to take multiple shots of the same event so you can pick the best shot later. While tapping the camera button repeatedly would be too slow, the iPhone's Burst mode can help. It allows you to take multiple photos almost instantly by simply tapping and holding the camera button. The longer you hold the button, the more photos are taken in burst mode.

Once you release the button, the photos are saved in a special folder in the Camera Roll called the Burst folder. To see the photos in the Burst folder, you can follow these steps:

1. In the Photos app, tap the Burst folder to select it.

2. Tap Select in the middle-bottom toolbar.

3. Navigate through the different photos in the burst set, as shown in Figure 1-6.

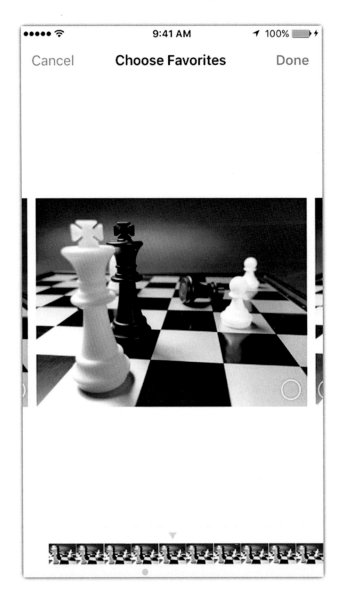

Figure 1-6. *Select the different images in the burst set*

To select one photo in the folder, you can do the following:

1. Select the image and tap Done at the top right of the screen, as shown in Figure 1-6.

2. Either tap Keep Everything to keep the folder and save the selected image (or images) as a separate image or tap Keep One Favorite to keep the selected image only and delete the rest.

Once either of the options is selected, the selected image (or images) is separated from the Burst folder and added to your photos as a normal photo.

Set Up Manual Focus and Exposure

By default, the iPhone camera sets the focus in your photo automatically toward the nearest object in the composition. However, you may need to change this such as when you want to focus on a far object in the shot. The iPhone gives you the option to manually set the focus and exposure of the photo by simply tapping the object you would like to focus on; the camera will shift the focus in the shot to the selected object, as shown in Figure 1-7.

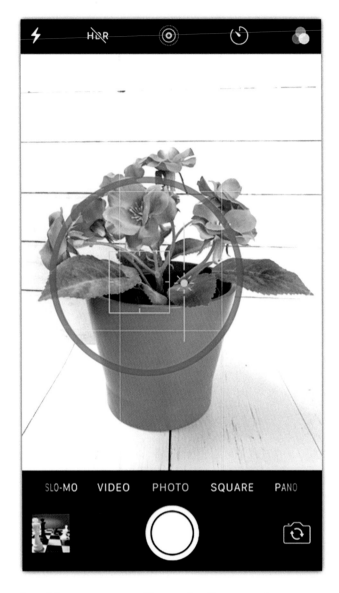

Figure 1-7. *Tap the object to manually set the focus and exposure*

After setting up the focus to the selected element, the exposure of the photo may change based on the light conditions in the image. If you want to modify the exposure, tap and drag up and down to open the exposure slider, which allows you to increase or decrease the exposure in the photo.

Lock the Exposure and Focus

Even though the iPhone gives you the flexibility to set the exposure and the focus in a shot, it has a drawback, especially when you are taking a photo where the elements may move. Or you might want to take multiple images of the same scene without changing the focus each time you take the shot.

To lock the focus and exposure, you can do the following:

1. Wait for the camera to optimize the photo exposure and photo.

2. Tap and hold on the screen until the yellow AE/AF Lock label appears at the top of the screen, as shown in Figure 1-8.

3. Tap the screen and drag up and down to change the shot brightness.

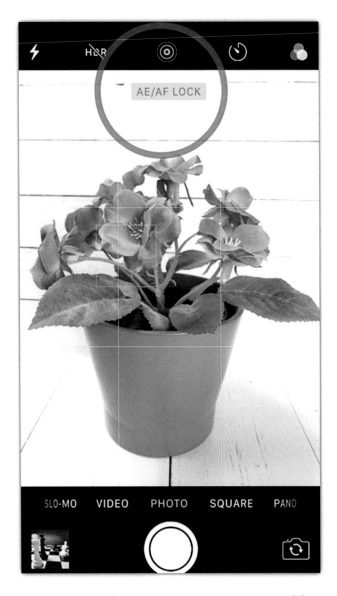

Figure 1-8. *The yellow label indicates that the exposure and focus are locked*

Note that if you close the Camera app and open it again, you need to set the lock again on the new shot.

Take HDR Photos

High dynamic range (HDR) photos are a combination of photos of the same shot taken using different exposure values. Merging between these photos creates a dramatic effect in the photos that is known as the *HDR photo effect*. Unlike normal images, HDR photos include more contrasting colors and variations of shades and light.

You can activate the HDR photo effect by simply tapping the HDR icon at the top of the screen to activate it, as shown in Figure 1-9. Note that taking photos of moving subjects using this technique may cause distorted images because the tool allows you to take three images with different exposures and merge them together. So, it is better to use this effect with still subjects.

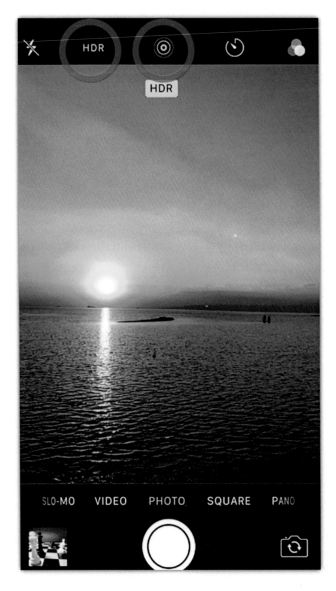

Figure 1-9. *Tap the HDR icon at the top of the screen*

While you take the HDR photos, you may like to keep the normal images for further work. To do this, you need to change the HDR setting.

1. Select Settings ➤ Photos & Cameras.

2. In the HDR section, turn on the Keep Normal Photo option.

Take Live Photos

A feature that was added to the iPhone camera starting in iPhone 6s/6s Plus is Live Photos. As you take pictures, the Live Photos feature records a small segment of video associated with the image. When you tap and hold on the image, the image starts to move, showing how the elements were moving while taking the shot. Live Photos also supports audio, so it is like having an image with a small video associated with it.

To activate the Live Photos feature, tap the Live Photos icon at the top of the camera screen before taking your shot. When you tap the camera button, iPhone records 1.5 seconds before and after the shot, which creates a total of three seconds of video with audio.

To play the video, you need to open the photo and then tap and hold on it to start the video. This type of photo is supported in desktop viewers such as the Photos app on Apple computers.

Quickly Access Different Photo Types

The iPhone camera allows you to take a variety of photos including regular, square, panorama, video, slow motion, and time lapse. The default method to switch between these modes is to access the Camera app and slide above either shutter button to select the photo or video type you would like to take. The quickest way to access these types is through 3D touch (available in iPhone 6s and 6s Plus and newer). Tap and hold firmly on the Camera app icon on your phone; the quick actions appear, and you can choose the type of photo you would like to take, as shown in Figure 1-10.

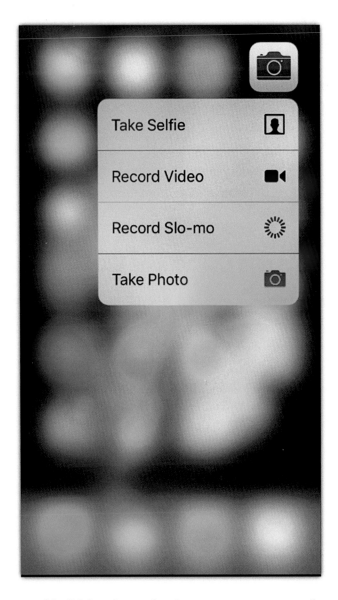

Figure 1-10. *Tap and hold firmly on the Camera app to open the quick actions menu*

Getting the Most Out of the Photos App

The default application that allows you to manage your photos on the iPhone and on Mac computers is the Photos app. It helps you to save, import, and manage photos taken using the iPhone. It also allows you to organize photos in albums, share photos, and save them on cloud services such as Apple iCloud, Dropbox, and others.

While many of the iPhone photography applications allow you to store photos in the application itself, saving the photos in the Photos app allows you to easily move between applications to apply different photo effects. Therefore, it is important to learn how to effectively use the Photos app.

Use the Moments and Collections Views

By default, when you open the Photos app, it displays the recent photos, but you can also review the photos based on the timeline of when you took them using the Collections view.

When you are in the Moments view (the default view), tap Collections at the top left of the screen, as shown in Figure 1-11. This will display the photos based on the month and where you took the photos. You can tap the months in order to zoom back to the Moments view. When the Collections view is active, tap the Years view to display the photos based on the year they are taken in. Then, you can tap each year to access the Collections view.

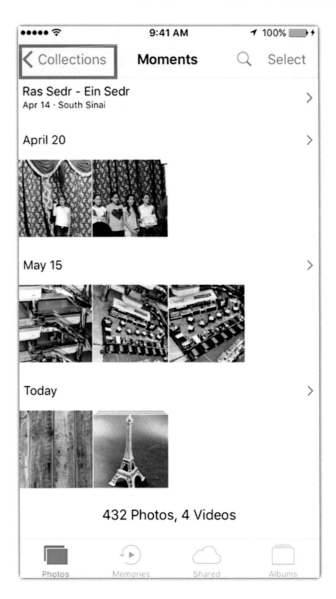

Figure 1-11. *Tap Collections to review photos based on a timeline*

Find Photos on Your Mobile Device

When your phone is full of photos, you need a way to find specific photos other than scrolling between them. The search feature in the Photos app provides a smart way to search for photos using different keywords including the following:

- The time when the photo was taken, such as the year or the month.

- The place where the photo was taken in. This can be a city, a country, or a specific location.

- An element placed inside the photo that can be named, such as a dog, a car, a beach, and so on.

- A person's name in the photo based on the people saved in the People folder, as you will see in the following tip.

Save People's Faces

By default when you take a photo and save it in the Photos app, the app tries to identify the people in the photo and saves the faces in the People folder. To take advantage of the face recognition feature in the Photos app, you need to assign a name for each recognized person in the People folder as follows:

1. Open the People folder in the Photos app's Albums folder.

2. Select one of the identified faces and tap it; the face will be displayed along with the photos that include it.

3. In the name field at the top of the screen, add the name of the person, as shown in Figure 1-12. A drop-down list shows the names in the contact list. Select a name from the list.

Figure 1-12. *Add the name of the person in the name field*

If the photo of a person is displayed more than one time, this means the application couldn't identify that those are actually one person. So, you can apply these same steps with the second face photo for the same person and include the same name. The application will ask you to merge the two data to unify all the images of the selected person.

After applying these steps, use the search feature as highlighted earlier to search for the person's name; you will notice all the person's photos are displayed in the search results.

Add Photos to Your Favorites and Create Albums

Sometimes you take a number of shots of the same scene and want to "favorite" one of these shots to be able to filter or use it later in photo editing. You can add photos to the Favorite folder with these steps:

1. Tap the photo to open it. Note that you don't need to open it full-screen.

2. Tap the Favorite icon in the bottom bar, as shown in Figure 1-13.

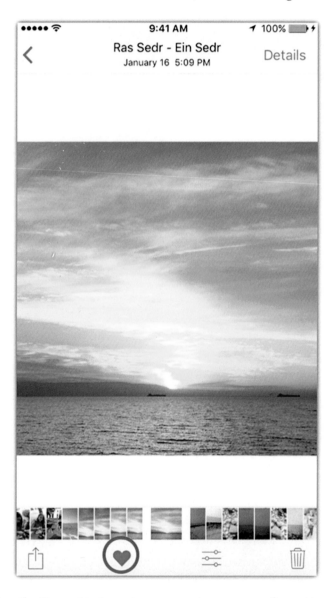

Figure 1-13. *Tap the Favorite icon to save an image as a favorite*

You can also organize photos by adding them to new albums; you can create a new album by doing the following:

1. Tap the Albums icon on the bottom right of the screen.

2. Tap the plus icon on the top right side of the screen.

3. Add the new album name and tap Save, as shown in Figure 1-14.

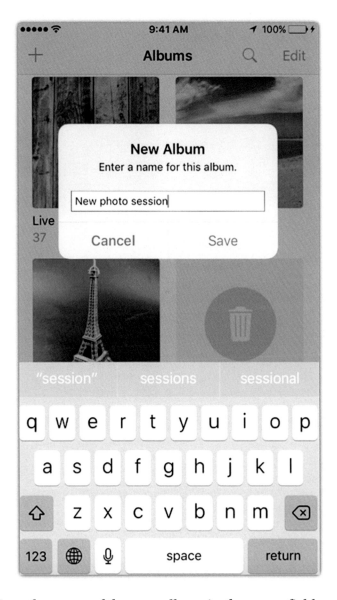

Figure 1-14. *Type the name of the new album in the name field*

To add a photo to an album or the newly created one, you can do the following:

1. Access the Camera Roll or any of the folders.

2. Tap the Select icon at the top right of the screen.

3. Select a photo or a number of photos.

4. Tap Add To at the bottom of the screen.

Select the album you want to add the photo to or tap New Album to create a new album and add the photo to it, as shown in Figure 1-15.

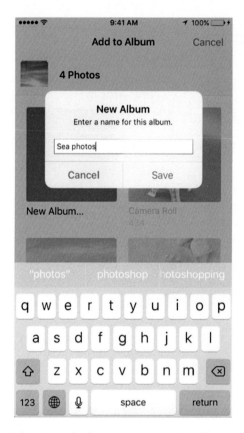

Figure 1-15. *You can add selected photos to existing albums or create a new album*

Summary

Your iPhone comes with advanced photography capabilities to help you take professional photos. Both the Camera and Photos apps include helpful features that can boost your iPhone photography skills. The Camera app includes hidden features that allow you to take photos quickly even without tapping the camera button. Also, it allows you to create different effects, such as Live Photos videos and HDR photos. Further, it gives you the option to modify the exposure and focus of a photo either automatically or manually. The Photos app extends your ability to organize photos in albums and favorites, and you can use the search feature to look up photos based on the people in it, objects, and dates. The next step is to start practicing these basic features before moving forward to more advanced options in the next chapters.

Practice Exercise

In this practice exercise, explore the different features in your iPhone. Take a number of photos of your favorite places, organize these photos, and add them to an album in your Photos app. Share it in the book's group on Facebook and comment on other people's photos.

CHAPTER 2

Photo Retouching Techniques

In the previous chapter, you learned how to efficiently use the Photos app and the Camera app on your iPhone to take photos and organize them into albums. In many situations, taking photos using an iPhone is spontaneous: you notice an interesting scene or an action, so you grab your phone and take the shot. Unfortunately, the spur-of-the-moment nature of taking photos using mobile devices increases the chances of having problems related to colors, light, and composition. These problems can be frustrating, but you can fix them using the default Photos app or a wide range of apps that can be downloaded (either for free or a cost) from the Apple App Store. This chapter's tips go through the steps to make these types of basic modifications on images.

Fix a Photo's Colors

Tools used: Photos app, Adobe Lightroom app

A common problem when taking photos is poor lighting, which can cause bad color conditions. This is something that can't be easily overcome when taking photos with your phone because you would need to carry external light sources and gear to fix the issues. So, when you take photos using your phone, you may have to modify the colors. You can do this by changing a photo's properties such as the hue, saturation, contrast, temperature, and so on.

Many photo-editing applications can help you to modify the photo's color settings. Here, you will explore how to modify the image colors using the Photos app on your mobile device and the Adobe Lightroom app that you can download for free from the App Store.

31

© Rafiq Elmansy 2018
R. Elmansy, *Developing Professional iPhone Photography*, https://doi.org/10.1007/978-1-4842-3186-9_2

Modify Colors Using the Photos App

With the recent updates of the iPhone's iOS, the Photos app has offers basic photo modification tools that can help you modify your photos without the need to install any third-party applications. These tools work fine, and you don't have to fill your phone with many applications, especially if your phone has limited storage capacity. To edit a photo's colors using the Photos app, follow these steps:

1. Open the Photos app and tap the photo you want to edit to display it full size.

2. Tap the adjustment icon at the bottom of the screen (Edit in previous versions). This allows you to access photo-editing mode, as shown in Figure 2-1.

Figure 2-1. *Accessing photo-editing mode in the Photos app*

3. Tap the editing icon, as shown in Figure 2-2, to access the edit
 options for Light, Color, and B&W. The Light options allow you
 to modify the light in the image, Color lets you modify the color
 properties, and B&W lets you convert the photo to black and white.

Figure 2-2. *The editing icon allows you to access the Light, Color, and B&W settings*

4. Tap the Color item to expand it.

5. Drag the Saturation slider to the left (moving the saturation red
 line to the right) to increase the saturation of the colors.

6. Tap the icon at the top right of the slider, and select Contrast in the
 Color section, as shown in Figure 2-3.

7. Drag the Contrast slider to the left (moving the contrast red line to
 the right) to increase the contrasted colors.

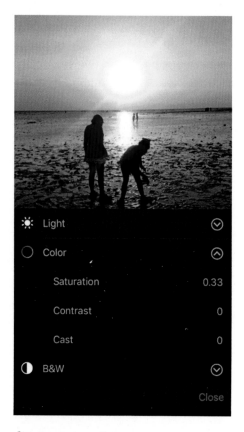

Figure 2-3. *The Color adjustment options*

Remove Photo Casting

Sometimes when you take photos in certain light conditions such as on cloudy days, in fluorescent light, or in warm light, the photo's colors get affected with the surrounding light conditions, which creates a color casting effect. This effect can spoil the natural colors in an image. In other cases, you'll want to add a cast color to create a special effect on the image, for instance, when adding a warmer effect to the image. To remove or add a color cast, follow these steps:

1. Tap the editing icon, and select the Color section.

2. Tap the icon at the top right of the color slider.

3. Tap Cast in the Color section, as shown in Figure 2-4.

Figure 2-4. *The Cast option under the Color adjustments*

4. Drag the slider to the left to create a warmer effect or to the right to create a cooler effect, as shown in Figure 2-5.

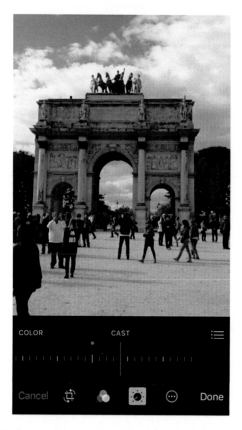

Figure 2-5. *Drag the slider to the right or left side to control the casting effect in the photo*

Make a Color Adjustment Using Adobe Lightroom

Adobe Lightroom is the most powerful application for photo managing and editing. It gives you advanced capabilities for modifying a photo and its details. It is commonly used by professional photographers and photo editors. A "lighter" version of the application is available to download on your iPhone from the Apple App Store. To use the application, you need to create a free Adobe ID. The free version allows you to capture, organize, and share photos from your mobile device. If you have an Adobe Creative Cloud membership, you have access to the extended features of the application; you can save source formats and integrate between both the mobile and desktop

applications. If you signed up with Adobe with the free account, you will only have access to the basic main adjustment functions in the Lightroom mobile app.

In this tip, you will use the Lightroom mobile app to edit a photo's colors. You can use similar steps to adjust the light in the Photos app.

1. Install Adobe Lightroom from the Apple App Store, and open the app after installing it.

2. Choose a photo from the existing Lightroom library or tap the Camera Roll button to open images from the phone's existing albums. Also, you can tap the Camera icon on the bottom right of the screen to take a photo using the phone's camera and add it to the Lightroom library. The photo opens on the screen, as shown in Figure 2-6.

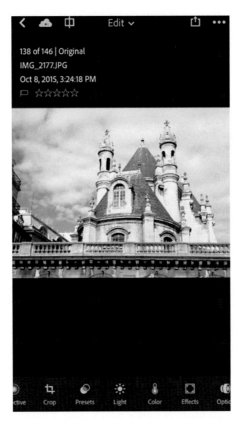

Figure 2-6. *Tap the photo to open it in Adobe Lightroom*

3. Tap the Color icon at the bottom of the screen to open the Color
 adjustment options.

4. Use the White Balance drop-down list to change the color tone in
 the photo based on the surrounding colors, as shown in Figure 2-7.
 You can choose from the existing options, or you can choose a
 custom white balance using both the Temperature and Tint values.

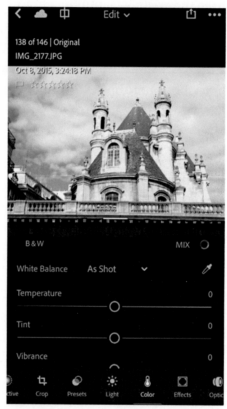

Figure 2-7. *Adjusting the white balance in the Color setting*

5. Use the Vibrance and Saturation sliders to affect the color
 intensity and vibrancy in the photo. Increasing the Vibrancy value
 creates brighter colors. Saturation sets the amount of color in the
 photo; for example, reducing the Saturation to -100 absorbs all the
 light from the photo and creates a black-and-white photo effect, as
 shown in Figure 2-8.

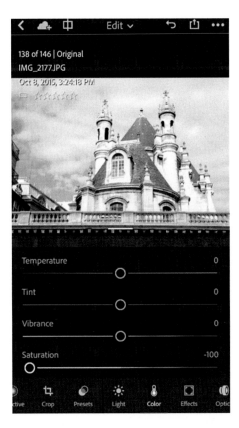

Figure 2-8. *Reduce Saturation to -100 to create a black-and-white effect*

You can also convert the photo to black and white by simply tapping the B&W button at the top left of the color adjustment panel. This option allows you to only modify the temperature and tint of the photo after converting it to black and white.

Perform Advanced Color Modifications

The color adjustment panel in Adobe Lightroom gives you even more advanced features to modify an image's color. You can change the color based on a specific area in the photo or by selecting a color range to be modified without affecting the rest of the colors in the shot.

To modify an image's colors based on a specific spot in the photo, follow these steps:

1. In the Adobe Lightroom app, tap the Color icon at the bottom of the screen.

2. Tap the eyedropper icon at the top right of the color adjustment values in the panel. The magnifier will appear on the photo, as shown in Figure 2-9.

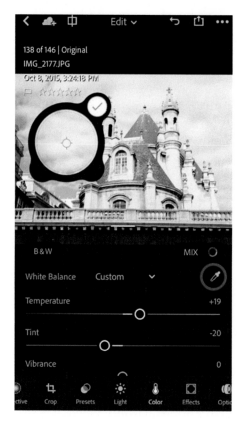

Figure 2-9. *The magnifier appears so you can select a color to adjust*

3. Drag the magnifier to the area where you want to change the color tones. You will notice that the colors in the photo change based on this sample.

4. You can modify the color using the sliders in the panel and customize your color tone.

In this example, you'll modify an image's color based on a specific area, which may include a number of colors. Additionally, you can modify the image based on a specific selected color or number of colors, which can be selected and modified individually as follows:

1. From the color adjustment panel, tap the Mix icon at the top right of the panel.

2. The colors that are included in the photo will appear as swatches at the top of the panel. From this color range, pick the color that you want to modify; you can change its properties such as Hue, Saturation, and Luminance, as shown in Figure 2-10.

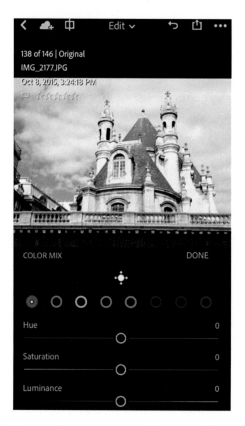

Figure 2-10. *The Mixed icon allows you to edit a specific color in the photo*

3. You can also tap the color picker icon.

4. At the bottom of the panel, select which value you would like to change, Hue, Saturation, or Luminance.

5. Tap the color in the image to modify and drag to change its properties. Notice that the selected color will appear in the color list in the panel to show which color is changed, as shown in Figure 2-11.

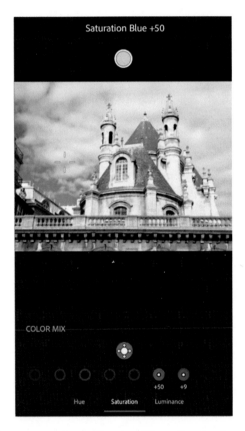

Figure 2-11. *Adjust the saturation of a specific color in the photo*

Crop and Resize Photos

Tools used: Photos app

Sometimes you take a photo and you want to crop it to focus on the main elements in the scene or to remove unwanted parts from it. You may also need to rotate the photo or flip it. The new iOS provides an easy method to crop images using the Photos app. Follow these steps:

1. Open the photo you want to crop in full-size view in the Photos app.

2. Tap the Edit icon in the bottom bar to enable the editing mode.

3. Tap the Crop icon on the left side.

4. Resize the rectangle around the image by dragging the edges of the rectangle.

5. Tap Done to apply the changes and crop, as shown in Figure 2-12.

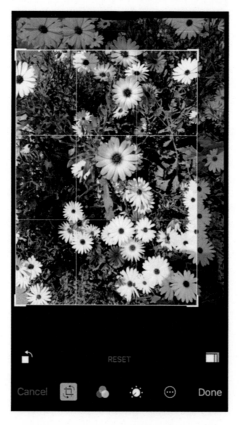

Figure 2-12. *Using the Crop icon to crop an image*

If you want to crop the image to a standard document ratio, you can tap the ratio icon on the bottom right to select the ratio before cropping the image.

You can also rotate the image and crop it. To do that, drag over the angle's area to rotate the image toward a specific angle; the image will be cropped and rotated to the needed angle, as shown in Figure 2-13.

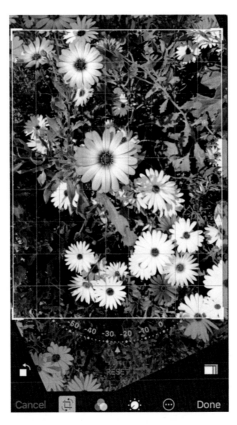

Figure 2-13. *Using the Crop icon to rotate an image*

If you want to flip the image to any of the four directions, you can tap the flip icon on the bottom left of the screen.

Remove Backgrounds

Tools used: Photoshop Mix app

To merge between a number of photos, you may need to remove the background from an image to make it transparent to be able to add it to another image. There are a number of applications that allow you to remove backgrounds such as TouchRetouch, Eraser, and Photoshop Mix. If you are familiar with the desktop version of Adobe Photoshop, you will find yourself familiar with most of the Photoshop Mix app features. In this section, you will explore how to remove the background from one photo and place it in front of another background.

1. Open Adobe Photoshop Mix.

2. Log in with your Adobe ID (free or paid subscription). Tap the plus icon in the top right of the screen, as shown in Figure 2-14.

Figure 2-14. *The Adobe Photoshop Mix projects*

3. Tap Image to open an image from the Camera Roll, as shown in Figure 2-15. Then, tap Select On My iPhone.

Figure 2-15. *Adding images to the Photoshop Mix project*

4. In the bottom bar, tap Cut Out to open the selection tools, as shown in Figure 2-16.

Figure 2-16. *Tap the Cut Out icon from the application bar*

5. Tap the Smart tool at the bottom.

6. Tap the settings icon on the left. Set it to Subtract, as shown in Figure 2-17.

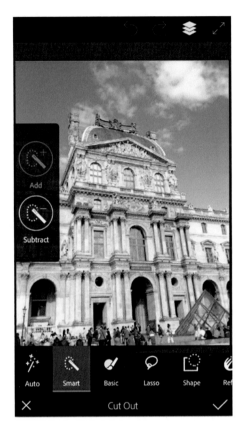

Figure 2-17. *Set the Smart tool to Subtract*

7. Drag over the sky or the background that you would like to remove, as shown in Figure 2-18.

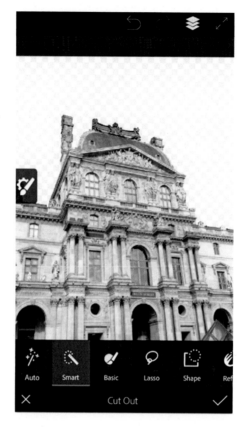

Figure 2-18. *The image without the background after removing it*

8. Zoom in and drag over the small areas to remove it.

9. Tap the Correct icon on the bottom right to apply the changes.

After removing the background, you will add a new background to the original image, as shown here:

1. Tap the Layers icon to display the layers on the right side of the screen.

2. Tap the plus icon to add a new layer, and choose to add a new image layer, as shown in Figure 2-19.

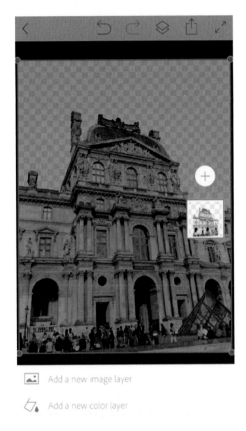

Figure 2-19. *Adding an image as a new layer*

3. Select the new background image from the Camera Roll.

4. Tap and hold the top background layer and place it behind the base layer, as shown in Figure 2-20.

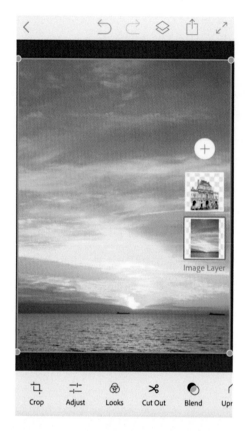

Figure 2-20. *Rearranging the layers in the project*

5. Use the rectangle around the image to resize it to fit in the
 background, as shown in Figure 2-21.

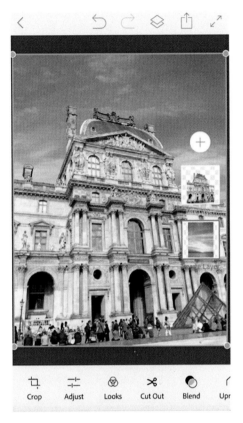

Figure 2-21. *Resize the background image to fit behind the top layer*

Sometimes there is a color difference because of the casting between the two images. So, the next step is to adjust the color of the top image to match the color in the background image.

1. Select the top layer from the Layers panel on the right side.

2. Tap the Adjust icon on the bottom left.

3. Tap Temperature to open the slider.

4. Drag the slider to the right to give the image a warmer tone, as shown in Figure 2-22.

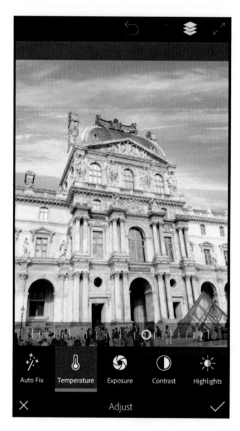

Figure 2-22. *Adjust the temperature of the photo using the Temperature icon*

Master Selections

Tools: Photoshop Mix

Adobe Photoshop Mix provides a number of tools that help you to select objects on your iPhone. These tools are trying to simulate the selection methods in the desktop version of the Adobe Photoshop application, as shown in Figure 2-23.

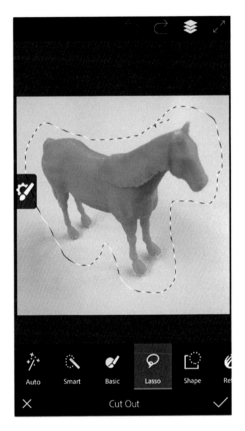

Figure 2-23. *Using the Lasso selection tool*

When you select an image to edit, you can tap the Cut Out icon at the bottom of the screen and choose any of the following tools:

- Tap the Auto icon to automatically detect the background and remove it. Note this feature requires a high contrast between the background and the elements in the image.

- Tap the Smart icon to drag over the elements that you want to select. This tool helps you to make a smart selection while dragging over the parts you would like to select. It uses the color similarity as a guide to select and remove parts.

- The Basic icon lets you drag to select the areas in the image. Unlike the Smart selection, this icon lets you manually define the areas that need to be removed.

- The Lasso tool lets you create a selection about specific areas in the photo as you draw with your finger or use the drawing pen around the area you would like to select.

- The Shape selection lets you make a selection based on a shape such as a rectangle, a circle, a triangle, or a square.

- Use the Refine icon to modify the smoothness of the selected area and how it blends with the background. You can also tap the Reset icon to return to the original version.

Remove Elements from a Photo

Tools: Photoshop Fix

Adobe Photoshop Mix allows you to manipulate images, but Photoshop Fix includes tools that allow you to fix issues that may appear in the photos. In this section, you will explore how to remove the unwanted parts from an image using Photoshop Fix. Follow these steps:

1. Open the Photoshop Fix app and log in with your Adobe ID.

2. Tap the plus icon at the top right.

3. Choose the source where you will get the photo, and select the photo, as shown in Figure 2-24.

Figure 2-24. *Adding a photo to a project in Photoshop Fix*

4. Tap the Healing icon at the bottom of the screen.

5. Tap the Spot Healing icon from the bottom bar.

6. Paint over the area you would like to remove. You can also use other tools such as the Patch and Clone Stamp tools, as shown in Figure 2-25.

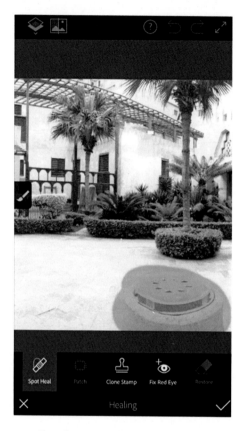

Figure 2-25. *Painting over the element that needs to be removed*

7. Tap the Correct icon to commit the changes. The final result should look like Figure 2-26.

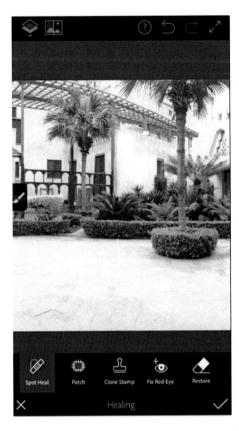

Figure 2-26. *The final result of the photo after removing the element*

Summary

Many applications can help you to edit and modify photos on the iPhone. These applications vary based on their capabilities. The mobile versions of Adobe apps provide a number of applications that can help you to edit photos in an environment similar to the desktop applications. You can use Adobe Lightroom to adjust the color and light in a photo to create a professional-looking outcome. You can use Photoshop Mix to merge different photos and select specific parts in a photo. To fix a photo, for instance, removing unwanted parts of the image, you can use Photoshop Fix.

Practice Exercise

In this practice exercise, take a photo using your iPhone and use Photoshop Fix to remove an object from the photo. Save the photo and use Photoshop Mix to blend it with another photo and then adjust the colors in the final composition.

CHAPTER 3

Working with Photography Projects

The newest DSLR cameras allow you to create different photography techniques easier than before. You can simply apply effects such as shallow depth of field and double exposure directly in your DSLR camera without the need to use computer applications such as Photoshop or Lightroom. While an iPhone camera doesn't give you the same tools you have in your DSLR, the good news that there are tons of applications that can help you to achieve similar effects.

In this chapter, you will go through a number of the photography techniques that you have probably used with a professional digital camera. You will try to create similar techniques using different iPhone apps. Remember to read through the steps first and then try them with your own photos.

© Rafiq Elmansy 2018
R. Elmansy, *Developing Professional iPhone Photography*, https://doi.org/10.1007/978-1-4842-3186-9_3

Creating Advanced HDR Photos

Tools used: Snapseed

Figure 3-1 shows the original photo I used for this example. You can work through the same steps using your own photo.

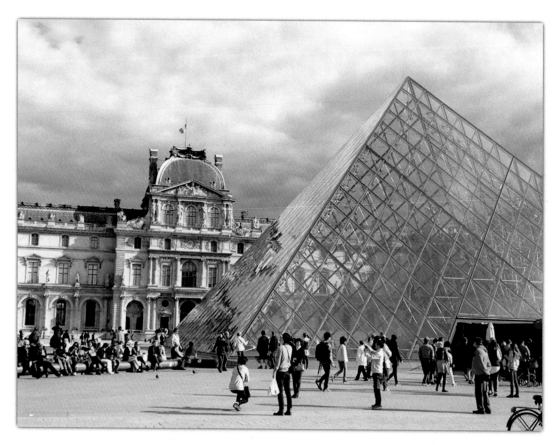

Figure 3-1. *The original photo (© Rafiq Elmansy)*

Figure 3-2 shows my final result.

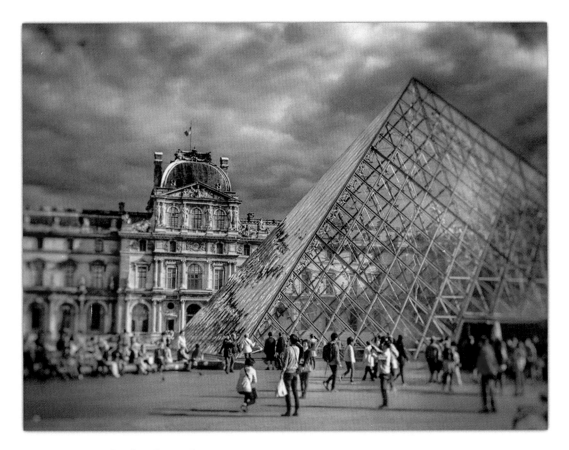

Figure 3-2. *The final result*

The high dynamic range (HDR) effect increases the contrast between the light and shadows in your photos by presenting a greater range of luminance levels compared to traditional images. This enables you to create photos with dramatic effects. As you explored earlier in this book, you can create HDR photos directly from your Camera app while taking your shot. However, the iPhone feature is still basic and doesn't give you full control over the effect. For example, you can't control the density or the style of the HDR effect applied.

HDR photos are usually created by merging a number of photos with different exposure levels to produce a wider range of luminance in the scene. Meanwhile, to reach a good result with the HDR effect, the photo needs to include colorful elements with high-contrast light and shadows. I took the photo in this tip while I was visiting the Louvre Museum in Paris a couple of years ago; I want to give its color more depth and drama. So, I used the HDR feature in the Snapseed app.

Step 1: Prepare the Photo

Before applying the HDR effect, you need to make sure that the photo colors are vibrant enough and contrasted to get better final results. To increase the brightness, contrast, and saturation in the shot, follow these steps:

1. Open the Snapseed app. Tap Open and open an image on your iPhone.

2. Tap the Tools button on the bottom right, and choose Tune Image. Tap the Adjustment icon, and choose Brightness. Drag the slider on the top to +20 to increase the brightness of the photo (see Figure 3-3).

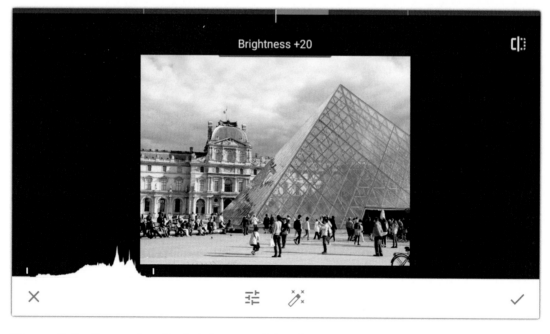

Figure 3-3. *Increasing the brightness of the photo in the Snapseed app*

3. Tap the Adjustment icon, choose Contrast, and set the value to +50.

4. Tap the Adjustment icon, choose Saturation, and increase it to +30. Set Ambiance to +30 (see Figure 3-4).

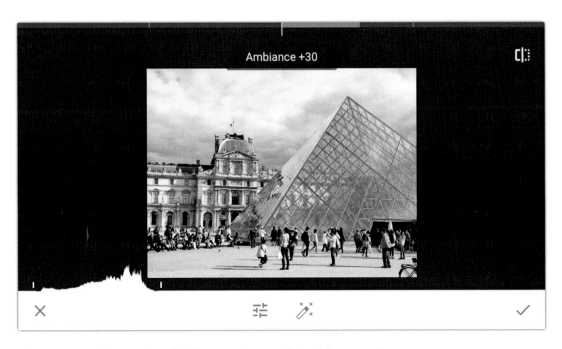

Figure 3-4. *Increasing the Saturation and Ambiance values*

5. Tap the Apply icon on the bottom right to apply the effect.

6. Tap the Tools button on the bottom right, and choose White Balance. You will give the colors in the photos a warmer effect (see Figure 3-5).

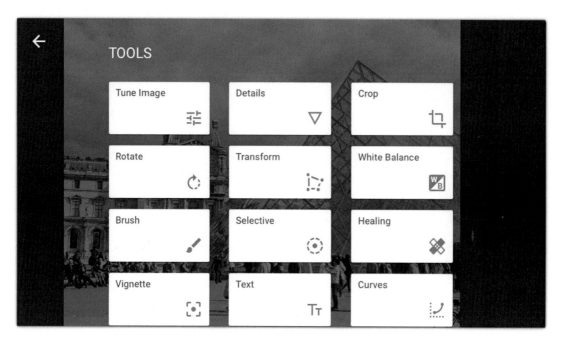

Figure 3-5. *Tap the White Balance setting*

7. Tap the Adjustment icon, and choose Temperature. Set it to a warmer level, for example, +10. Tap the Apply icon (see Figure 3-6).

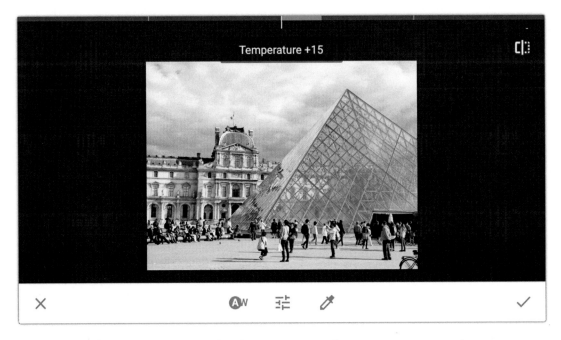

Figure 3-6. *Adding a warm effect by increasing the Temperature setting*

Step 2: Apply the HDR Effect

You should choose an HDR effect that is suitable for the photo you have. Follow these steps:

1. Tap the Tools icon, and choose HDR Scape from Filters.

2. Choose the Strong mode, and increase its strength to +50 (see Figure 3-7).

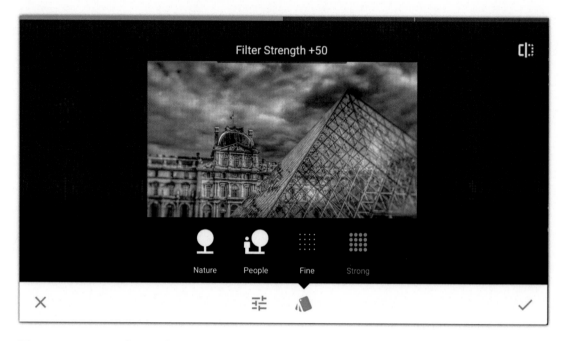

Figure 3-7. *Applying the HDR Scope effect*

3. Tap the Adjustment icon, choose Brightness, and set it to be a little brighter by dragging the slider to +10.

4. Tap the Apply icon.

Step 3: Apply the Vignette Effect

To add more focus to the center of the photo and the glass pyramid, I will add a vignette effect to create darker edges for the shot. You can use your own photo to create a similar effect. Follow these steps:

1. In the Tools list, choose Vignette. Drag the slider to the left to create darker edges in the photo (see Figure 3-8).

2. Tap the Apply icon.

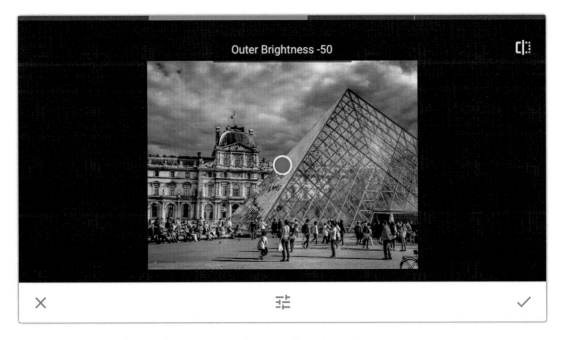

Figure 3-8. *Applying the vignette effect to the photo*

Step 4: Add the Blur Effect

In addition to the vignette effect, you will add a blur effect to increase the focus on the center of the photo. Follow these steps:

1. In the Filters list, choose Lens Blur. Increase the blur strength, for example, to +30.

2. With two fingers, drag to adjust the size and shape of the blur applied to the photo. Try to make the blur on the edges only so that the center point of the photo is in focus.

3. Tap the Apply icon (see Figure 3-9).

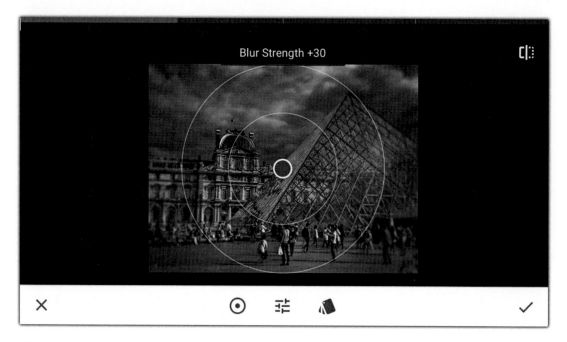

Figure 3-9. *Applying the blur effect*

4. Tap Save to save the changes. Then choose to save a copy to
 preserve the original photo untouched. When you save the photo,
 you can open again and edit the modifications. If you choose
 Export, the photo will be exported, yet the changes won't be
 editable.

Creating a Shallow Depth of Field

Tools Used: Tadaa

Figure 3-10 shows the original photo I used for this example.

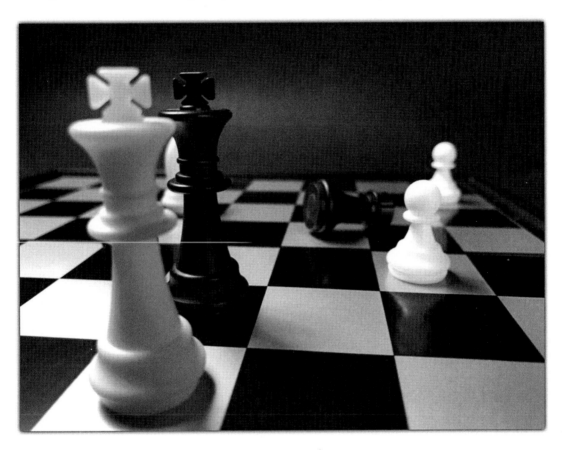

Figure 3-10. *Original image (© Radwa Khalil)*

Figure 3-11 shows my final result.

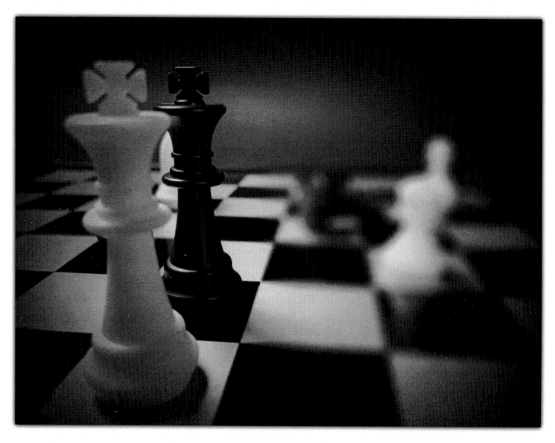

Figure 3-11. *Final result*

The term *depth of field* refers to the focus range in the shot. If the photo's focused area is limited to the near objects while the far elements appear blurry, it is called a *shallow* depth of field. On the other hand, if the focused area includes a large area of the photo, it is called a *deep* depth of field. The depth of field in a DSLR camera is controlled by the camera aperture (f-stop), which is related to the diameter of the lens opening, and it is represented as a fraction of one (1/F). So, if the lens opening is large, the number becomes small, which results in a shallow depth of field.

On the iPhone, the aperture control is limited while taking a photo because you are only able to tap the object you would like to focus on. Sometimes you need to have more control over the shot's depth of field. In the following example, I took the shot but later decided to tweak the depth of field. There are many apps that can help you manually apply a shallow depth of field on the photo such as Camera+ and Tadaa.

In the following example, I wanted to give more focus to the near chess pieces while blurring the far objects. Also, I wanted to apply darker edges to the photo to focus on the main objects in the shot. Find a similar photo to follow along with the example.

Step 1: Protect the Main Objects

Before applying the blur effect, you should protect the main objects in the shot to keep them sharp. You can use a mask effect as follows:

1. Open a photo in the Tadaa app, and tap the Blur icon in the bottom toolbar.

2. Tap the Edit Mask icon at the top.

3. Zoom in the objects and start to paint a mask over them. Here, I painted the pieces near the camera (see Figure 3-12).

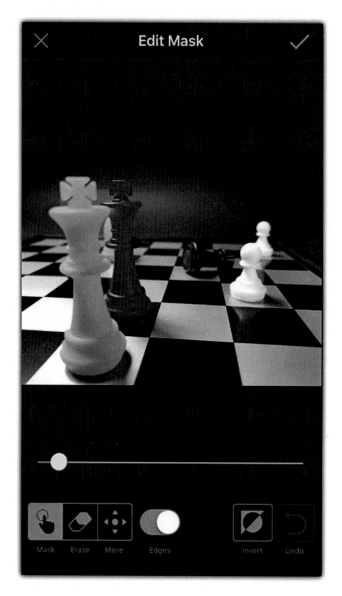

Figure 3-12. *Applying a mask over the elements near the camera*

4. Tap the Apply icon at the top right.

Step 2: Apply the Blur Effect

Now, I will apply the blur effect to the far objects in the shot. You can follow along with
your own photo.

1. Tap the Blur icon. You may need to drag the toolbar right or left to reveal the rest of the tools (see Figure 3-13).

Figure 3-13. *Drag the toolbar to reveal the Blur icon*

2. Set the blur type to Circular.

3. Drag with your fingers to resize and position the protected area above the near objects in the photo.

4. Drag the Blur slider to increase the blur effect on the far objects. The amount of blur varies based on visual distance between the near objects and the far objects.

5. Reduce the Range value to start the blur effect from a proper distance from the in-focus objects (see Figure 3-14).

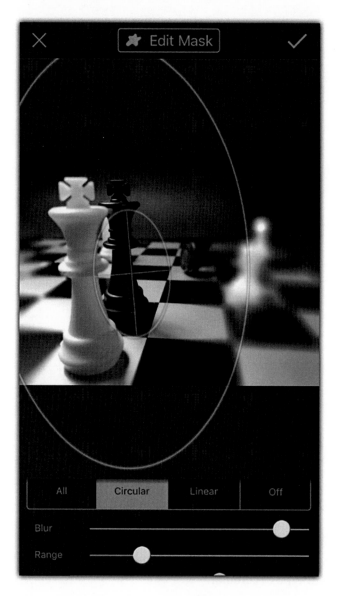

Figure 3-14. *Apply the blur effect on the far objects in the photo*

6. Tap the Apply icon.

Step 3: Apply the Vignette Effect

Now, you will darken the edges of the photo to focus on the main objects as follows:

1. Tap the Vignette icon in the bottom toolbar.

2. Drag Intensity to the left side to create a proper frame around the photo.

3. Drag the Range slider to a middle point (see Figure 3-15).

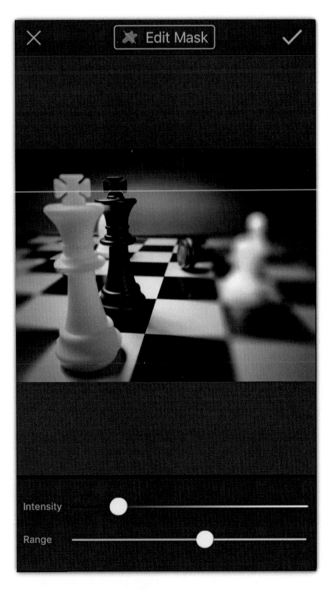

Figure 3-15. *Applying the vignette effect*

4. Tap the Apply icon at the top right.

Step 4: Apply a Final Filter

After adding the vignette effect, you will add a filter to the photo to give it a dramatic mono color effect, as follows:

1. Tap the Filter icon, and choose Charleston filter.

2. Drag the slider under the filter a middle point to soften the effect of the filter (see Figure 3-16).

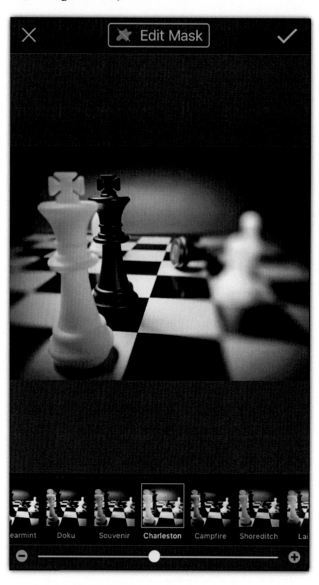

Figure 3-16. *Applying the vignette effect*

3. Tap the App icon, and tap the Share icon to save the photo to your Camera Roll.

Creating a Low-Light Black-and-White Photo

Tools: Adobe Lightroom app, Adobe Photoshop Mix

Figure 3-17 shows the original photo I used for this example. Choose a similar photo to follow along with the example.

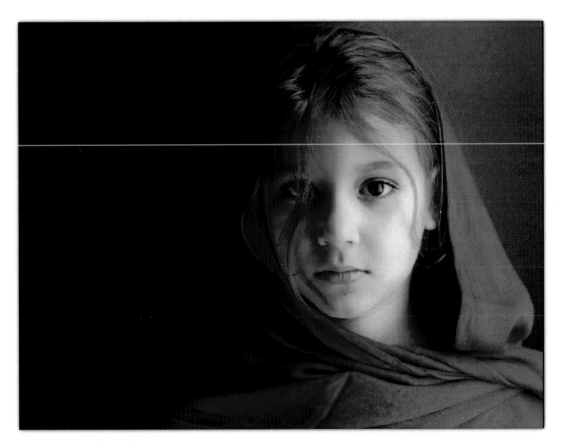

Figure 3-17. *The original photo (© Radwa Khalil)*

Figure 3-18 shows my final result.

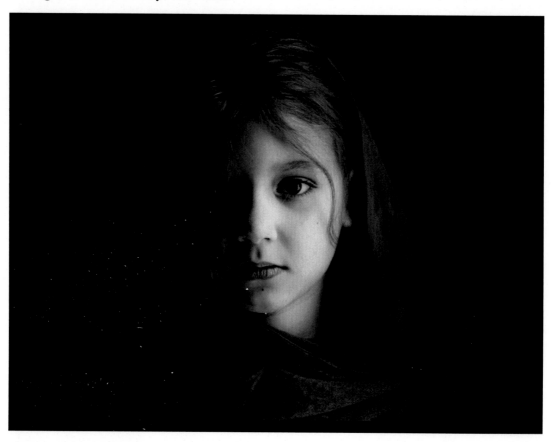

Figure 3-18. *The final result*

A low-light effect allows you to create a dramatic effect on a photo by having viewers focus on the lit part of the photo. Usually, it works well with portrait photography as it emphasizes the facial expressions. To ensure high contrast in a low-light photo, you need to consider the following tips:

- Take your photo against a dark background, such as solid black. You can use a black wall or paper in the background of your object.

- Limit the number of objects in the photo to one object or person to ensure precise focus and the ability to control the photo's light and dark areas while editing.

- Try to use a soft low-light source facing the person or the object in the shot.

- Try to use a tripod to ensure a steady shot with your iPhone.

In the following example, the photo was taken with a soft light on a black background, which makes it suitable for a low-light effect. I used Photoshop Mix to improve the white areas using layers and blending modes.

Step 1: Convert a Photo to Black and White

First, bring a photo to the Lightroom app to convert it to black and white and then adjust the overall exposure, contrast, light, and shadows.

1. Open a photo in the Adobe Lightroom app.

2. Tap the Color icon. Tap the B&W icon on the top left of the menu. This will convert the image to black and white.

3. Set the temperature to +40 and the tint to +45 (see Figure 3-19).

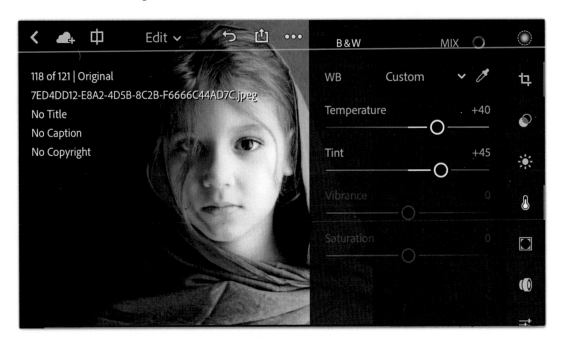

Figure 3-19. *Convert the photo to black and white and increase the Temperature and Tint settings*

4. Tap the Light icon, and set Exposure to -1, Contrast to +100, Highlight to +5, Shadows to -85, Whites to +55, and Blacks to -55 (Figure 3-20).

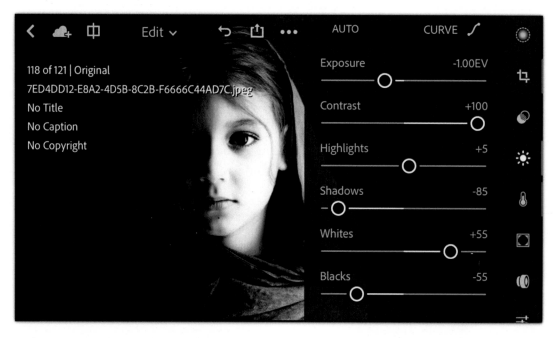

Figure 3-20. *Adjusting the light settings to create a more dramatic light*

5. Tap the Effects icon and set Clarity to -45 to create a smooth effect on the face details.

6. Set Vignette Amount to -50 to increase the black around the edges of the shot (see Figure 3-21).

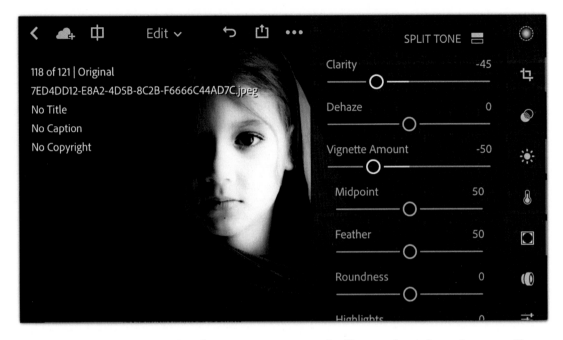

Figure 3-21. *Reducing the clarity to create a soft effect and apply a vignette effect on the edges*

Step 2: Focus on the Face

You can use the selective adjustment to modify parts of the photo without affecting the face. Follow these steps:

1. Tap the Selective icon to apply a partial adjustment to the right side of the photo.

2. Tap the Linear mask icon from the tools on the left, and drag to create a mask that goes from the right to the left of the photo and ends at the beginning of the face (see Figure 3-22).

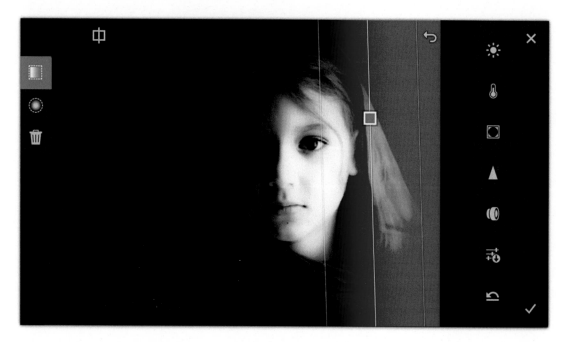

Figure 3-22. *Applying selective adjustment to the right part of the shot*

3. Tap the Brightness icon, and set the exposure to -1.60 to reduce
 the destruction on the left side of the face (see Figure 3-23).

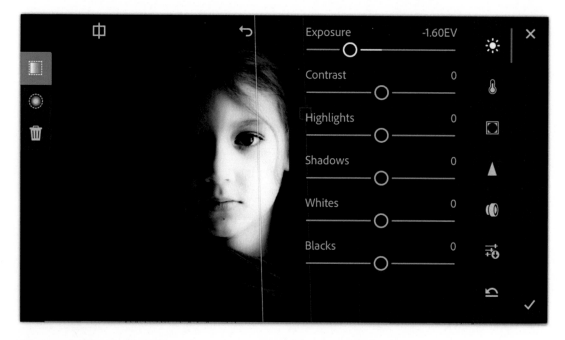

Figure 3-23. *Reduce the exposure on the right part of the image*

4. Tap the Apply icon on the bottom right.

5. Tap the Share icon, and tap Save to Camera Roll.

6. Set the quality to the maximum available.

Step 3: Improve Highlights

You might want to improve the highlighted part of the photo to increase its emphasis on the face. To do so, you can use Photoshop Mix to set the blending modes, as follows:

1. Tap the plus icon in Photoshop Mix. Choose Image, and navigate to the Camera Roll for the photo you just saved.

2. Tap once on the layer on the left to open its Properties panel. If you can't see the layers, tap the top-right icon to display the app tools.

3. Tap the Blend icon, and set the blending mode to Screen. Tap the Apply icon.

4. Tap the Looks icon to apply a filter. Choose Portrait, and tap the Apply icon.

Creating High-Key Photos

Tools: Adobe Lightroom app, Photoshop Mix app, Blur app

Figure 3-24 shows my original photo.

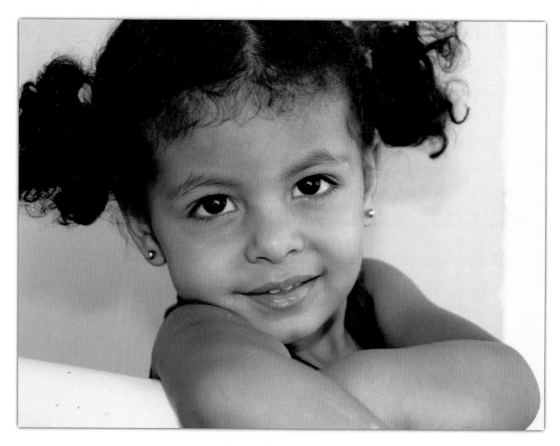

Figure 3-24. *Original photo (© Radwa Khalil)*

Figure 3-25 shows my final result.

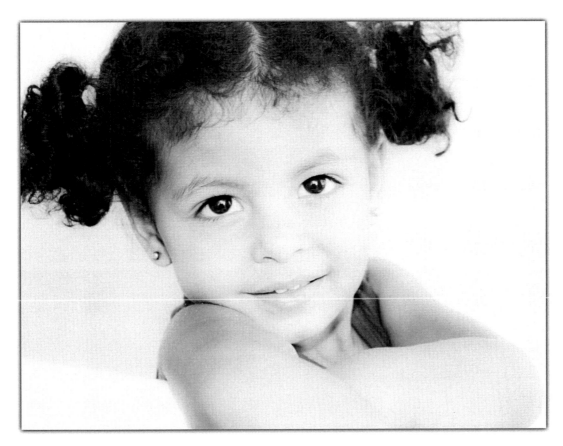

Figure 3-25. *Final result*

In contrast to low-light photos, high-key photos reduce the lighting ratio and contrast level in a photo to create more natural lighting. The technology was originally developed for screens that couldn't display contrast ratios, but now it is used to create a minimal and stylish effect on photos.

To take a good high-key photo, the shot should include a minimal number of objects so you can easily modify them using different applications. Try to take the shot in natural surroundings with a bright background in order to minimize the shadows in the photo.

Step 1: Convert to Black and White

First you can use the Lightroom app to convert your photo to black and white and increase the whites in the shot using curves.

1. Open the image in the Lightroom app. Tap the Color icon. Then, tap the B&W icon to convert the photo to black and white. Drag the Temperature slider to the right (see Figure 3-26).

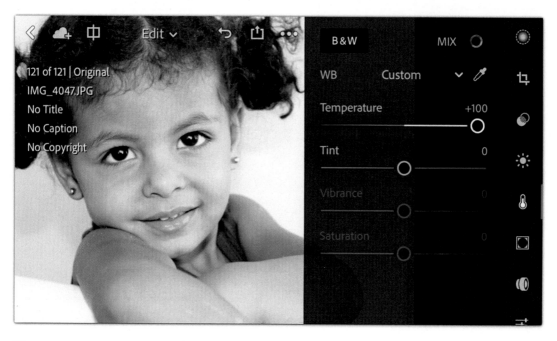

Figure 3-26. *Converting the photo to black and white*

2. Tap the Light icon. Tap the Curves icon to set up the curve to increase the light areas and increase the intensity of the blacks, keeping a smooth transition between them. Then tap Done (see Figure 3-27).

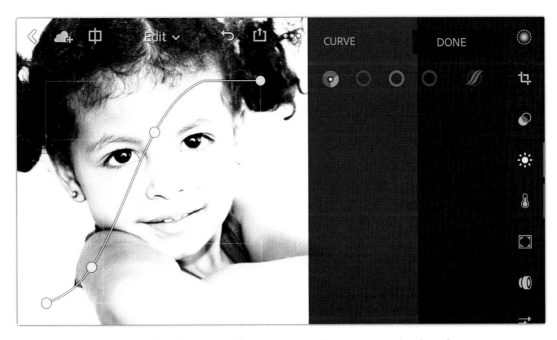

Figure 3-27. *Using the Curves tool to increase the contrast in the photo*

3. Drag the Highlight slider to the far right. Increase the shadows, whites, and blacks a little (Figure 3-28).

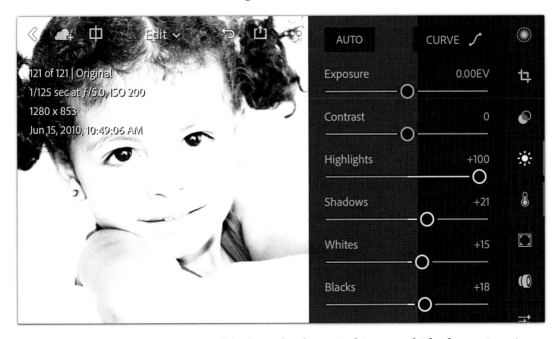

Figure 3-28. *Increasing the Highlights, Shadows, Whites, and Blacks settings in the photo*

89

4. Tap the Effects icon, and reduce Clarity to -65 to create smooth
 edges on the photo (see Figure 3-29).

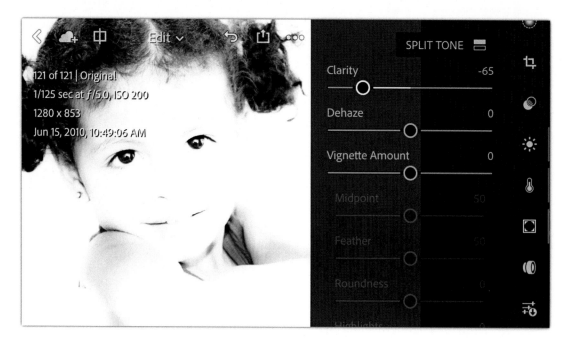

Figure 3-29. *Reduce Clarity to create a smooth effect*

5. Tap the Share icon, and save the image to your Camera Roll.

Step 2: Create a Blurred Version

To add a soft effect over the photo, you can create a blurred version of the photo you just
modified. Follow these steps:

1. Open the image in the Blur app. Tap the Adjust icon on the right of
 the toolbar. Set a low value, for example, 10.

2. Tap the Blur icon, and paint the light areas in the photo
 (see Figure 3-30).

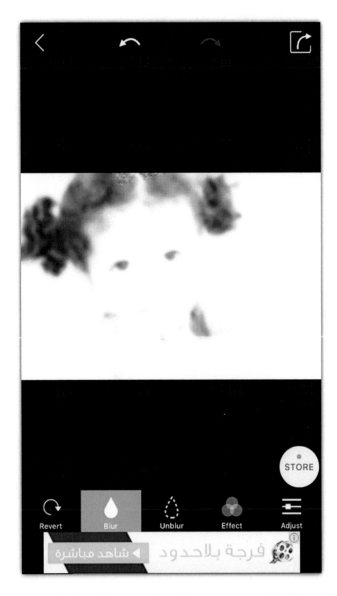

Figure 3-30. *Draw with the Blur app brush to increase the blur effect on the photo*

3. Tap the Save icon, and save the photo to your Camera Roll.

Step 3: Finalize the High-Key Photo

You can now add both photos in Photoshop Mix and use the layer opacity and blending modes to blend between the sharp and blurred versions of the photo. Follow these steps:

1. Open the Photoshop Mix app. Tap the plus icon on the top right to create a project. Add the first image from the Camera Roll.

2. Tap the plus icon to add a new layer. Choose to add an image and navigate to the blurred photo to add it (see Figure 3-31).

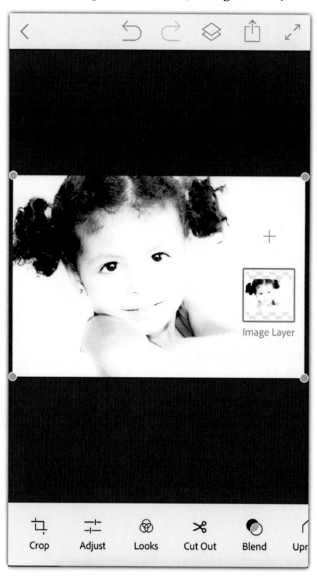

Figure 3-31. *Adding the blur version of the photo to the first one*

3. Double-tap the top layer to open its properties. Set Opacity to 65%, and set the blending mode to Overlay (see Figure 3-32).

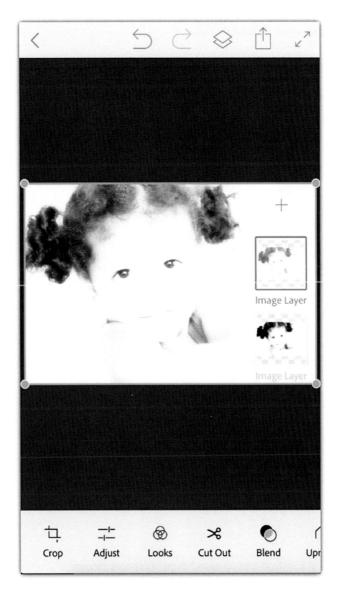

Figure 3-32. *Changing the opacity and blending mode for the blurred layer*

4. Tap the Share icon, and save the photo.

Creating Double-Exposure Photos

Tools used: Pic Blender

Figure 3-33 shows my original photo.

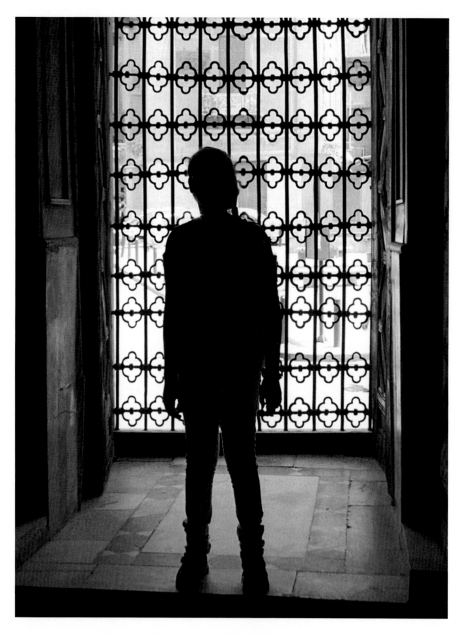

Figure 3-33. *Original photo (© Radwa Khalil)*

Figure 3-34 shows my final result.

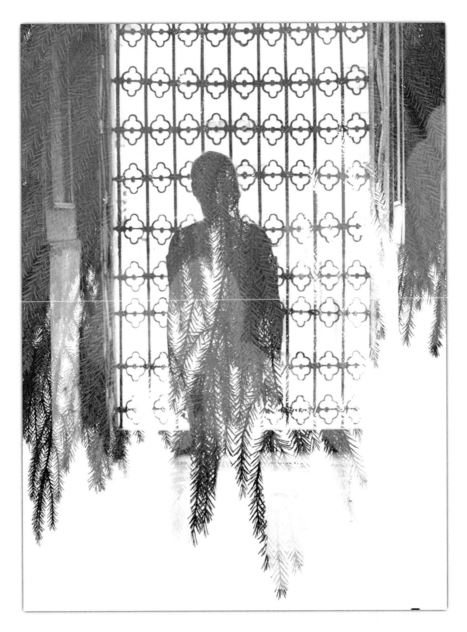

Figure 3-34. *Final result*

The double exposure, also known as multiple exposures, effect allows you to combine two or more photos into single manipulated one. It allows you to merge between the photos to display details from each one, using a photo to mask another one. Basically, the light and shadows in one image are used to display the details in the other image (or images). The technique has become popular in the last few years with the dramatic evolution of digital camera capabilities that allow photographers to create the double-exposure technique directly in their DSLR cameras.

The double-exposure technique also can be created after the fact using photo-editing applications such as Adobe Photoshop, which creates very good results like the ones created through a camera. Furthermore, it gives you more control over the effects and style used in the final result.

In addition, there are many iPhone apps that can help you take double-exposure photos such as Union, MultiExpo, Superimpose, Pic Blender, Pixlr, Fused, and Snapseed. In this tip, you will use the Pic Blender app to combine two photos to build the double-exposure effect. To create a good effect, make sure to select a base photo with contrasting colors and low details and pick a second one with details such as trees, buildings, and so on.

Step 1: Prepare the Base Photo

Before applying the double-exposure effect directly, you will adjust the photo to increase the contrast between the light and shadows in the photo.

1. Open the Pic Bender app, and choose a high-contrasted photo as the base one.

2. Tap the Adjustment icon and then tap the Contrast icon. Drag the slider to the right to increase it. This will increase the shadows and light areas in the photo and reduce the midtones (see Figure 3-35).

Figure 3-35. *Adjusting the contrast of the black-and-white photo*

Step 2: Combine Photos

Now, you will use one of the photos in the app as a second image to blend with the base one. Then, you will modify the second image to fit with the original one.

1. Tap the Photos icon on the left of the toolbar to add the second photo.

2. You can tap the Camera icon to take a photo or use one from your existing photos. Navigate to a tree photo, and choose a third one (see Figure 3-36).

Figure 3-36. *Selecting a tree photo as the second photo to blend with the original*

3. With your two fingers, flip your tree photo and enlarge it to fill the canvas.

4. Set the blending mode to Screen. Drag the slider to the far right
 (see Figure 3-37).

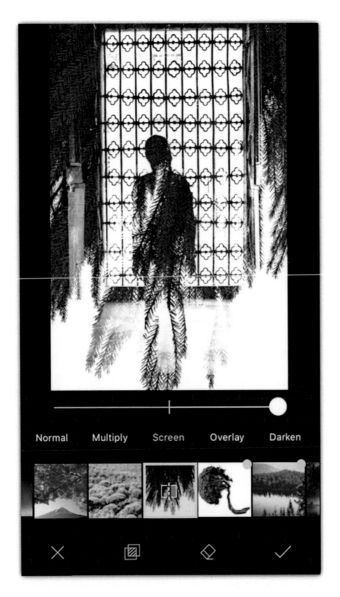

Figure 3-37. *Applying the blending mode to the tree photo*

5. Tap the Apply icon.

Step 3: Enhance the Double-Exposure Effect

After applying the double-exposure effect, you will apply a bokeh effect over the photo to add an artistic feel to the shot.

1. Tap the Effects icon. Choose the fourth image called Bokeh.

2. Set the blending to Screen, and drag the slider a little to the left to increase the image transparency (see Figure 3-38).

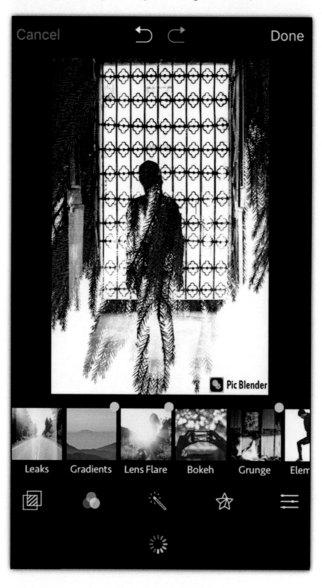

Figure 3-38. *Adding the bokeh effect to the photo*

3. Tap the Apply icon.

4. Tap the Filters icon, tap the Film Light icon, and choose the first effect.

5. Drag the slider to the left to reduce the effect a little (see Figure 3-39).

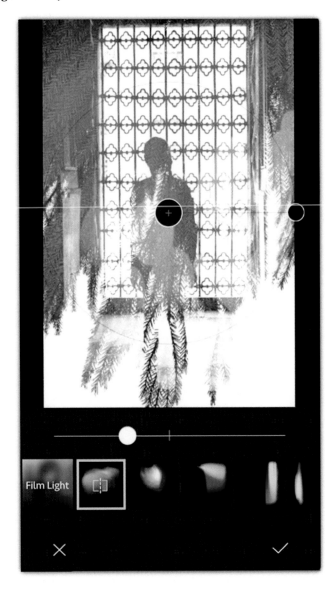

Figure 3-39. *Applying the Film Light filter effect*

6. Tap the Apply icon.

7. Tap Done.

8. Choose the desired resolution, and tap Save.

Summary

While the iPhone camera doesn't include advanced features such as low-light, high-light, HDR, and double-exposure effects like a professional DSLR camera does, you can still achieve these techniques using the large variety of free and paid apps that you can download from the App Store. You can also extend these features by using multiple applications to improve the final results. The tips in this chapter covered some of the photography effects that you can apply using your iPhone.

Practice Exercise

Start by taking photos that can be used in this chapter's tips. You can also use photos from your iPhone library. Start by applying the effects and practice the different settings and styles.

CHAPTER 4

Mastering Photo Editing and Applying Effects

In the previous chapter, you learned how to create effects such as HDR photos and shallow depths of field. Those tips were just the beginning. You can use apps from the Apple App Store to add filters, frames, and styles to your photos. You can also manipulate multiple photos to create a specific scene. Each tip in this chapter lists the apps that I used; you can use either use the same apps or choose similar ones.

Creating a Delicious Food Photo Collage

Tools used: Adobe Lightroom app, Moldiv app

In this tip, you'll learn the following:

- How to modify a photo's color and light

- How to create a photo grid or collage of several photos

- How to add texture to photos

Figure 4-1, Figure 4-2, and Figure 4-3 show the original photos that I used. Try to find something similar so that you can follow along.

© Rafiq Elmansy 2018
R. Elmansy, *Developing Professional iPhone Photography*, https://doi.org/10.1007/978-1-4842-3186-9_4

Figure 4-1. *First photo (© Radwa Khalil)*

Figure 4-2. *Second photo (© Radwa Khalil)*

Figure 4-3. *Third photo (© Radwa Khalil)*

Figure 4-4 shows my final result.

Figure 4-4. *Final result*

As the saying goes, a picture is worth a thousand words. Well, a photo collage can tell even more. Arranging photos in a collage or a grid allows you to tell a story; it's a great way to show different photos with the same theme to emphasize your point. While there are many applications that can help you to create a photo collage, it is important to prepare for your project even before taking your shots. Each collage should have a theme; in other words, the photos should be related in a specific way. Here are some examples:

- *Color theme collage*: In this theme, the photos may vary in subjects and location yet they are unified with the same color such as a blue sea, blue sky, and blue stones.

- *Object theme collage*: All the photos in this type of collage are displaying the same or related objects such as fruits, tree leaves, flowers, or people.

- *Storytelling collage*: This collage is used to tell a story or show sequenced photos of the same scene. For example, it may include kids playing a specific game and show four or more shots of their reactions while playing.

In this example, I will show how to organize a series of photos from a food photography session into a collage style. You will learn how to modify the colors of the photos in the Adobe Lightroom app first and then move to the Moldiv app to create the final collage effect.

Step 1: Modify the Photo Colors

In the Lightroom app, you will increase the vibrancy of your photos and increase their clarity to align the level of colors in all shots.

1. In the Adobe Lightroom app, tap the Camera Roll icon, and select the photo you want to use (see Figure 4-5).

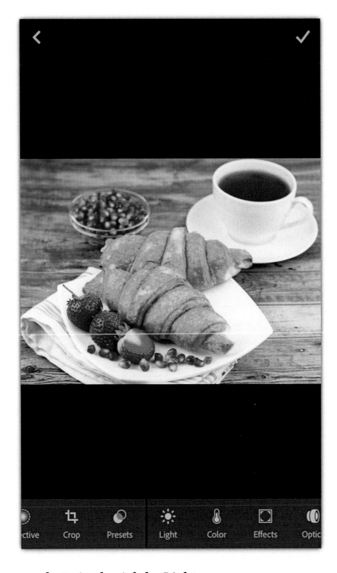

Figure 4-5. Open a photo in the Adobe Lightroom app

2. Tap the Color icon, and drag the Vibrance slider to the right to increase the vibrancy of colors (see Figure 4-6).

Figure 4-6. *Increase the photo's Vibrance value*

3. Tap the Effects icon, and drag the Clarity slider a little to the right side to increase the clarity of the photo (see Figure 4-7).

Figure 4-7. *Increase the Clarity value*

4. Once the photo color is modified, tap the Share icon, and choose Save to Camera Roll. For Image Size, choose Maximum Available.

Step 2: Build the Photo Collage

Follow these steps to build a photo collage:

1. Open the Moldiv app, choose Collage, and pick one of the photo collage layouts. For this example, choose the third one on the second row (see Figure 4-8).

Figure 4-8. *Choose one of the collage styles*

2. Tap one of the grids, and choose Albums. Navigate to the first
 photo to add it (see Figure 4-9).

Figure 4-9. *Add photos to the collage parts from the mobile album*

3. Repeat these step to add the other two photos in the other
 sections in the grid (see Figure 4-10).

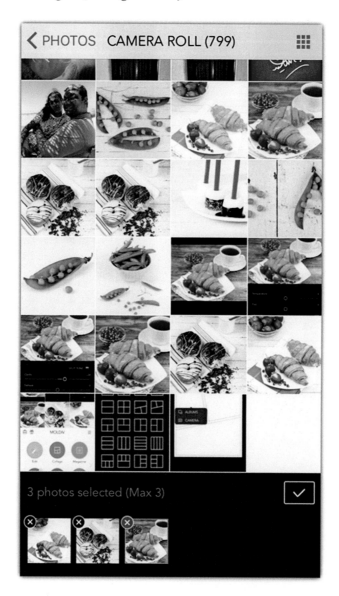

Figure 4-10. *Select the photos to add to the collage grid*

4. With two fingers, drag to change the size and focus on each image.
 Try to place the focus on the main subject in the photo to give an
 interesting look to the grid (see Figure 4-11).

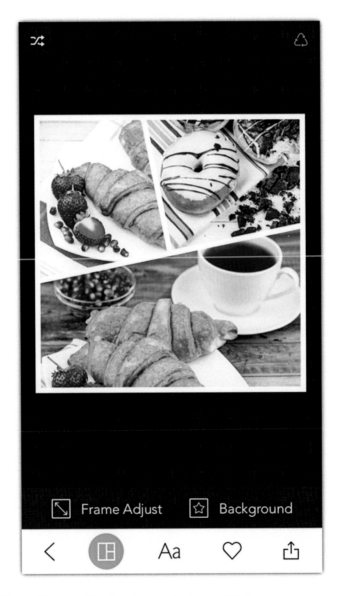

Figure 4-11. *The collage with the three photos added*

Step 3: Save the Photo Collage

Follow these steps to save your photo collage:

1. Tap the Share icon on the bottom right of the toolbar.

2. Set the size to Maximum. The collage will be saved to your Camera Roll in its full size (see Figure 4-12).

STANDARD (1200X1200)

MEDIUM (2048X2048)

MAXIMUM (3264X3264)

Figure 4-12. *Saving the collage with the maximum size*

3. Tap the Share icon, and tap Edit to continue to the next step.

Step 4: Add a Texture Effect

Follow these steps to add the texture effect:

1. Tap the Edit icon in the Share menu. If you closed it, you can tap
 the Edit icon from the app home and navigate to the photo collage
 (see Figure 4-13).

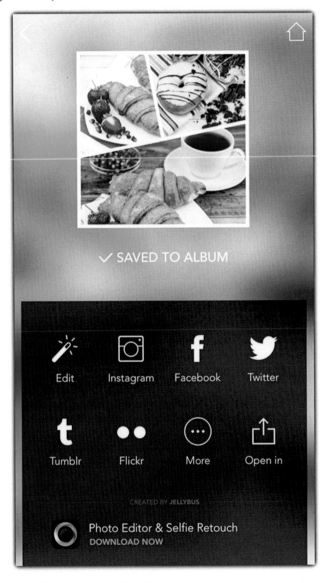

Figure 4-13. *Tap the Edit icon in the Share menu*

2. Tap the Filters icon to open the app filters. Tap the Basic filters, and choose Joker (see Figure 4-14).

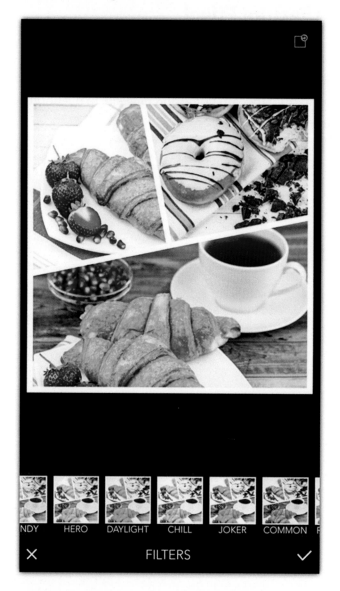

Figure 4-14. *Select the Joker filter to apply to the collage*

3. Tap the Apply icon on the bottom right.

Adding Vintage Style to Your Photos

Tools used: Spanseed, PicsArt, and Photofox

In this chapter, you will learn about the following:

- How to create a vintage effect and then improve it

- How to add filters such as a lens flare

Figure 4-15 shows the original photo I'm using.

Figure 4-15. *Original photo (© Rafiq Elmansy)*

Figure 4-16 shows the final result.

Figure 4-16. *Final result*

Vintage photos are a great way to evoke a nostalgic feeling when looking at them. While you can't create a vintage effect directly on your DSLR camera, it can be created on a desktop computer using photo-editing applications such as Adobe Photoshop. On your iPhone, you can create the vintage effect using various apps. Instagram, for example, allows you to apply a vintage filter after you take a photo and before sharing it with your followers.

In this tip, you will explore how to convert a photo to a vintage style using various applications. I used a photo of my daughter that was taken during our last trip to the Pyramids of Giza.

Step 1: Apply a Vintage Effect

Follow these steps to apply a vintage effect:

1. Open the photo in the Photofox app. Tap the Image icon in the bottom toolbar.

2. Tap the Tone icon in the bottom toolbar, and in the Filters list choose the E58 filter to create a warm vintage effect (see Figure 4-17).

Figure 4-17. *Applying the Photofox E58 filter*

3. Tap the Share icon, and save the photo to your Camera Roll.

Step 2: Add a Lens Flare

Follow these steps to add some lens flare:

1. Open the photo in the PicsArt app. Then tap the plus icon to add an image, and choose Edit.

2. Drag the toolbar to the left, and choose Lens Flare (see Figure 4-18).

Figure 4-18. *Adding the Lens Flare effect*

3. Select a proper lens flare effect from the list.

4. Set Hue to 0, Opacity to 48, and Blend to Add (see Figure 4-19).

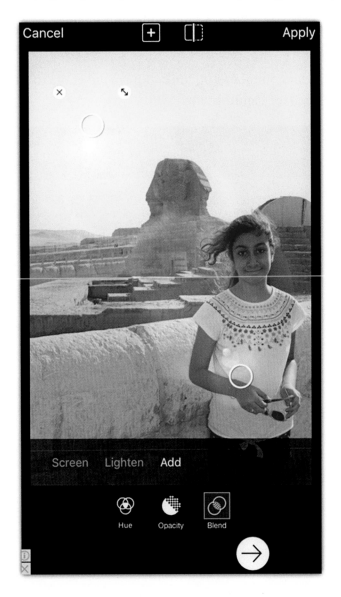

Figure 4-19. *Adjusting the lens flare position and intensity*

5. Tap the Next icon on the top right and save the photo in your Camera Roll.

Step 3: Improve the Vintage Effect

Follow these steps to improve the vintage effect:

1. Open the photo in the Snapseed app, and choose the Vintage filter from the tools.

2. Choose the filter number 6 on the bottom of the photo to add a blue gradient (see Figure 4-20).

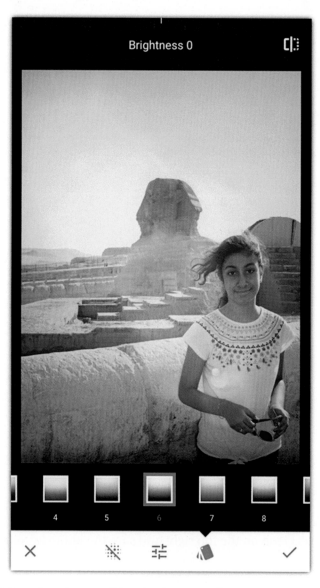

Figure 4-20. *Adding the vintage filter in Spanseed*

3. Tap the Apply icon.

4. From the Tools, choose the Grunge filter. Choose the fifth grunge effect.

5. Tap the Adjustment icon, and choose Texture Strength. Set the value to 15 (see Figure 4-21).

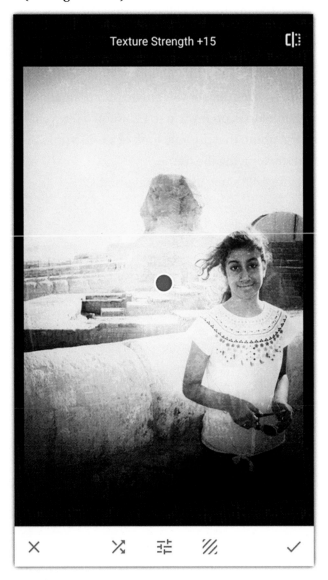

Figure 4-21. *Add the grunge effect and adjust it*

6. Tap the Apply icon.

7. Tap the Share icon and choose Save a Copy to save the photo without replacing the original one.

Creating Photo Frames

Tools used: Tadaa, Laminar Pro, and Photoshop Mix

In this section, you'll learn the following:

- How to convert the photo to a vintage style

- How to apply different types of frames to the photo

- How to manipulate two photos or more together

There are many applications that let you create photo frames for your shot. In this tip, I am using a photo that I took on my trip to Lebanon a few years ago. I want to give it a custom frame using a photo that my wife took of a tree trunk. But first, I will add a vintage color effect before applying the frame.

Figure 4-22 and Figure 4-23 show the original photos.

Figure 4-22. *Original photo (© Rafiq Elmansy)*

Figure 4-23. *Original photo of texture (© Radwa Khalil)*

Figure 4-24 shows the final results.

Figure 4-24. *Final result*

Step 1: Give the Photo a Vintage Effect

Follow these steps to give a photo a vintage effect:

1. Open a photo in the Tadaa app.

2. Tap the Filters icon, and choose the Shoreditch filter. Then tap the Apply icon (see Figure 4-25).

Figure 4-25. *Applying the Shoreditch filter in the Tadaa app*

3. Tap the Frame icon, choose a grunge frame, and tap the Apply icon (see Figure 4-26).

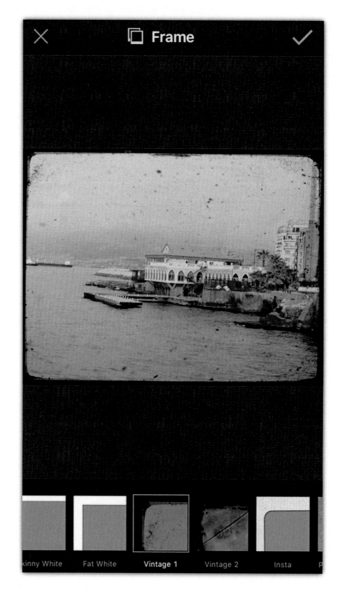

Figure 4-26. *Applying the vintage frame in the Tadaa app*

 4. Save the photo in the Camera Roll folder.

Step 2: Apply More Frames

Follow these steps to apply more frames:

 1. In the Laminar app, open the photo you just saved from the previous step.

2. Tap the Effects icon, and choose Borders.

3. Select the Snap and Stack border, and tap the Apply icon (see Figure 4-27).

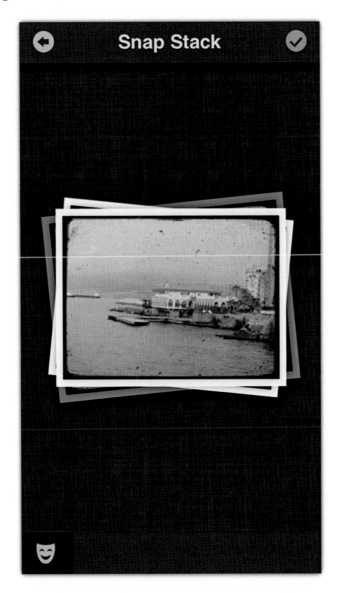

Figure 4-27. In Laminar app, apply the Snap and Stack border.

4. Tap the Share and Export icon. Set Output Format to PNG (this will create a transparent photo), and tap Library from the Save to menu.

Step 3: Add the Frame Background Texture

To add the frame background texture, follow these steps:

1. Open the tree texture in Photoshop Mix.

2. Tap the plus icon to add a new layer. Choose the frame image to add to the new layer.

3. Use your fingers to resize the top layer to fit with the size of the canvas (see Figure 4-28).

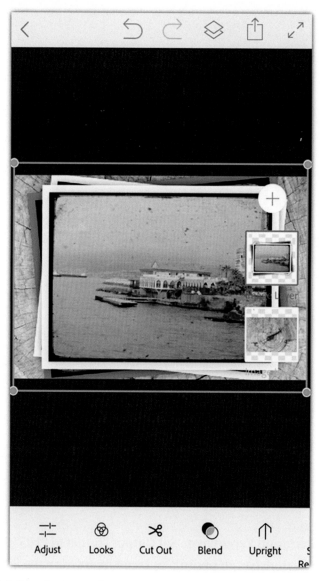

Figure 4-28. *Add the photo to the tree texture in Photoshop Mix*

4. Tap Looks, and choose the Punch filter.

5. Tap the Edit tool on the right of the screen, and choose Smart Selection.

6. Tap the Feather icon, and drag to the right to increase it.

7. Paint over the middle of the photo to keep the effect on the middle part of the photo and remove it from the edges (see Figure 4-29).

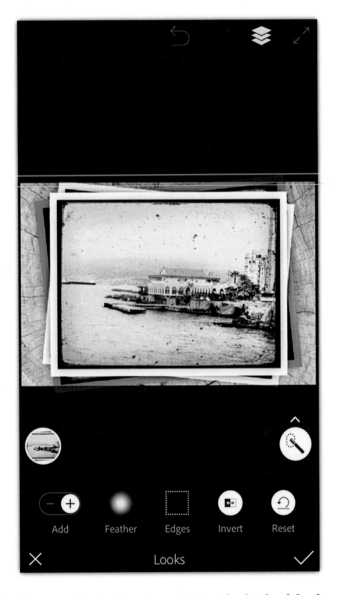

Figure 4-29. *Use the smart selection to optimize the look of the frame*

Creating a Film Stripe Effect

Tools used: Snapseed, Camera Awesome

In this tip, you'll learn the following:

- How to convert photos to black and white

- How to convert photos to monochrome

- How to crop and add texture to photos

- How to add a film strip effect to photos

Figure 4-30 shows the original photo I am using.

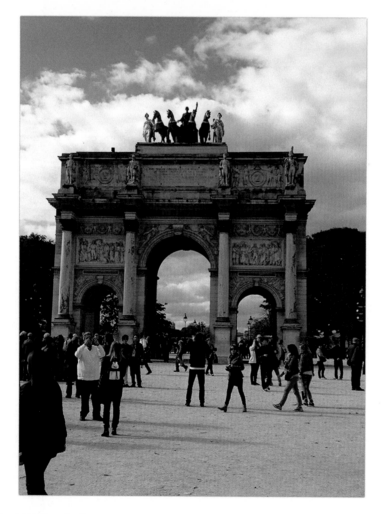

Figure 4-30. *Original photo*

Figure 4-31 shows the final result.

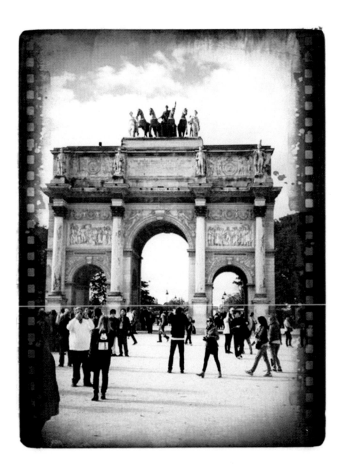

Figure 4-31. *Final result*

A popular trick in photo editing is to turn a photo into an old-style photo and change it to a film strip shape. To do this, you first convert the photo to black and white and give it a monochrome effect using the Snapseed app so that it's suitable for the final effect. Then, you can move to the Camera Awesome app where you will crop the photo to fit inside the film strip. In the same app, you can apply a sepia filter to the photo, then a texture, and finally the film strip.

Step 1: Convert the Photo to Monochrome

Follow these steps to convert the photo to monochrome:

1. Open the photo in the Snapseed app.

2. Tap the Tools icon, and choose Black & White. Choose a tone
 that makes sure that all the elements in the photo are clear and
 contrasted (see Figure 4-32).

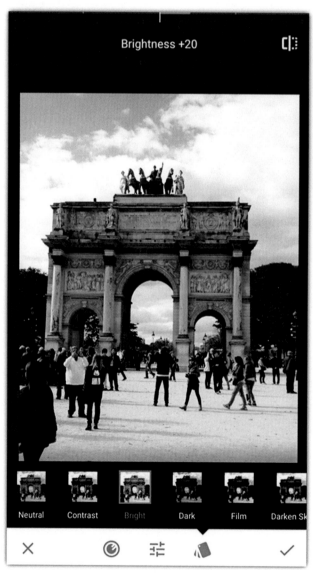

Figure 4-32. *Converting the photo to black and white*

3. Tap the Apply icon.

4. In the Tools list, choose the Vintage filter, and select a brown color filter. Tap the Apply icon (see Figure 4-33).

Figure 4-33. *Add a vintage color to the photo*

Step 2: Improve the Photo and Add the Frame

Follow these steps to improve the photo and add the frame:

1. In the Camera Awesome app, tap the photos icon on the left of the camera button. Tap the plus icon, and add the photos from your library.

2. Tap to open the image from the library, and then tap the photo to edit.

3. Tap the Transform icon, and set the crop size to a square. Then tap Done.

4. Tap the filters, apply the Sepia filter, and tap Done (see Figure 4-34).

Figure 4-34. Apply a Sepia filter in Camera Awesome

5. In the Texture section, choose a Family Album filter, and tap Done to apply it.

6. Tap the Frames icon, and choose the Sprockets frame. You can also apply other film-like frames. Then tap Done (see Figure 4-35).

Figure 4-35. *Add the film frame to the photo*

7. In the bottom toolbar, tap the Export to Camera Roll icon.

Highlighting Elements Using Color

Tools used: Photoshop Mix and Photo Splash

In this tip, you'll learn the following:

- How to fix issues in photos using layers

- How to convert photos to black and white

- How to colorize part of the photograph or decolorize it

Figure 4-36 shows the original photo I'm using.

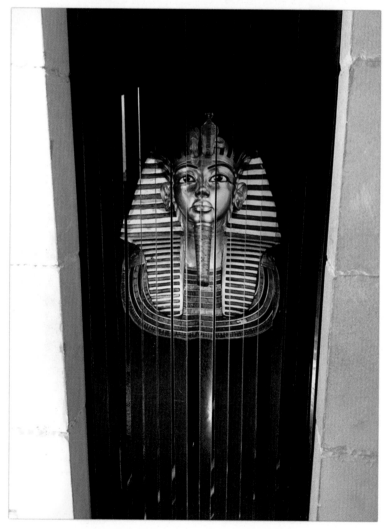

Figure 4-36. *Original photo*

Figure 4-37 shows the final result.

140

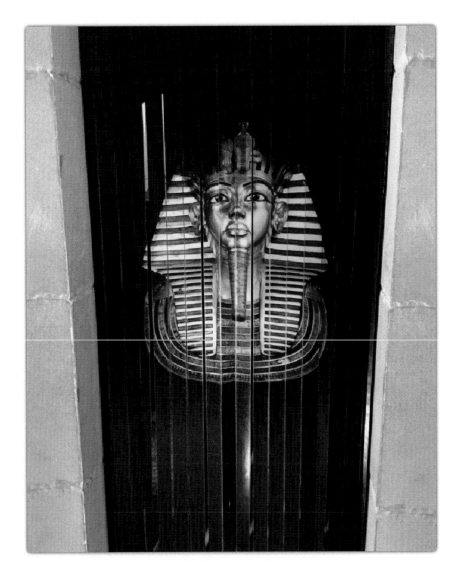

Figure 4-37. *Final result*

Sometimes you need to emphasize an object based on the photo's composition. This can be achieved using different methods such as color. One of the effects that can help you to focus on a specific element in the shot is colorizing an object while converting the rest of the photo to black and white. In this tip, I have a photo of a King Tut Ankamoun poster, and I would like to highlight the mask in the shot.

Unfortunately, the left side of the wall in the photo has very exposed light compared to the right side. So, I will show how to use Photoshop Mix to replace the left wall with a copy from the right side. Then, I will open the photo in Photo Splash to easily

Step 1: Fix the Photo Issues

Follow these steps to fix the photo issues:

1. Open the photo in Photoshop Mix. You need to replace the left side of the wall with a copy from the right side.

2. Tap the layer to open its properties menu. Then, tap Duplicate (see Figure 4-38).

Figure 4-38. *Open the photo in Photoshop Mix*

3. Select the top layer. Tap Cut Out.

4. Select the Smart tool, and then in the left settings tap Subtract. Drag over the photo to remove everything and keep the front side of the right wall (see Figure 4-39).

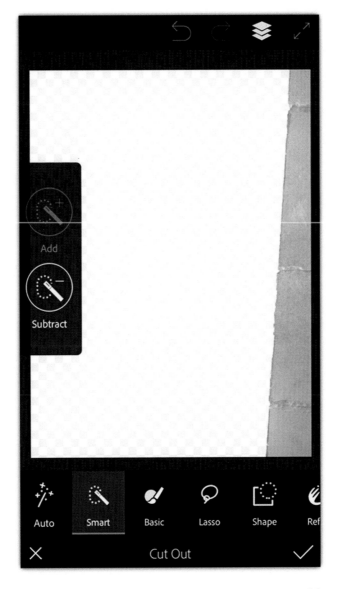

Figure 4-39. *Use the Smart tool to remove the layer elements and keep the right wall*

5. In the bottom toolbar, tap Refine. In the left settings, drag over the Feather value to set it to 15.

6. Tap the Apply icon.

7. Tap the right wall layer to open its properties, and tap Flip H.

8. Drag to place the right wall on the left side and modify its size and position as needed (see Figure 4-40).

Figure 4-40. *Reflect and position the wall to the left side*

9. Tap the Adjust icon, increase Highlights to 5%, and tap the Apply icon.

10. Use the Crop icon to crop the edges of the photo that still appear around the fixed area, and tap the Apply icon (see Figure 4-41).

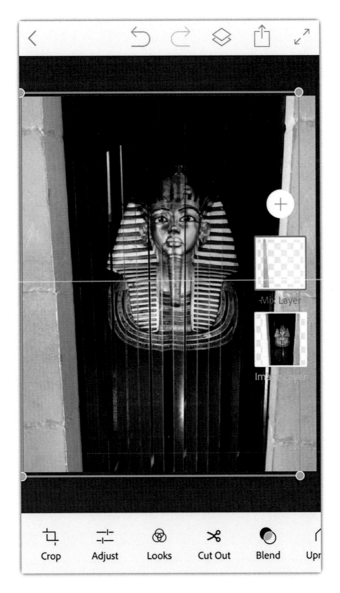

Figure 4-41. *Crop the unwanted areas from around the image*

Step 2: Convert the Photo to Black and White

Follow these steps to convert the photo to black and white:

1. Tap the Share icon, and save the photo to the Camera Roll.

2. Tap the plus icon to add a layer. Add the photo that you just saved to have a merged copy of the photo.

3. Tap the Adjust icon, and drag the Saturation value to the left to convert the photo to black and white (see Figure 4-42).

Figure 4-42. *Desaturate the layer colors to convert to black and white*

4. Tap the Apply icon.

Step 3: Add Color to the King's Mask

Follow these steps:

1. With the black-and-white layer selected, tap the Cut Out icon.

2. Tap the Basic icon, and in the left settings, tap Eraser.

3. Paint over the mask to remove the black-and-white version and display the colored version under it. Then tap the Apply icon (see Figure 4-43).

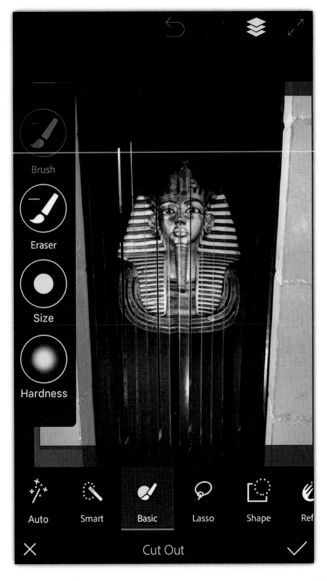

Figure 4-43. *Remove the black-and-white mask to display the colored one*

4. Tap the Share icon to save the final result to your Camera Roll.

Summary

In this chapter, you explored how to take photo editing further. The tips provided a number of examples of how to use applications to apply filters, add frames, and manipulate several photos for one project. You can the apps mentioned to try the exercises with your own photos and adjust the settings according to the nature of your shots.

Practice Exercise

Start by thinking about a photo that you can use to build a mystic or dramatic effect. Then, prepare the photo to fit with your idea. For example, remove the background and adjust the colors. Once done, you can build the composition in a layer-based application such as Photoshop Mix and Photofox.

Integrating with Adobe Lightroom on the Desktop

To expand your iPhone's photography capabilities, you can take the photos you have edited on your phone and integrate them with the Adobe Lightroom desktop application. One of the advantages of using the Adobe Lightroom mobile app is that it allows you to go from your phone to the desktop version of the same application. This allows you to continue modifying your photos but on a larger screen, which can help you to see more details in a photo.

In this chapter, you will explore how to extend your iPhone's photography capabilities using the integration between the Adobe Lightroom mobile app and desktop application. You'll take photos using the Camera Raw technology.

Rate, Flag, and Organize Photos

Before starting to integrate your files from your phone to the desktop version of Adobe Lightroom, you need to organize and filter the images so you can easily identify the best shots to use in further photo-editing steps.

The Lightroom app provides a comprehensive way to organize and arrange photos. In the Lightroom app on your phone, you can review and rate your photos in order to easily identify them for photo-editing projects. You can review the photos in Lightroom and rate them as follows:

1. Open the Lightroom app.

2. Select an image from the library or from the Camera Roll.

3. In the top menu, set the mode to Rate & Review.

149

© Rafiq Elmansy 2018

R. Elmansy, *Developing Professional iPhone Photography*, https://doi.org/10.1007/978-1-4842-3186-9_5

4. Swipe up and down on the left side of the screen to display the rating stars. You can give a rating to a selected image by dragging up and down. You can also use the stars at the bottom of the image to give it a rating, as shown in Figure 5-1.

Figure 5-1. *Swipe up or down on the left side of the photo to add a rating*

5. Swipe up and down on the right side of the screen to open the flagging option. This allows you to choose between flagged, unflagged, or rejected. Drag up or down to choose between the three options. You can also use the flag icon at the bottom right of the image to flag the image, as shown in Figure 5-2.

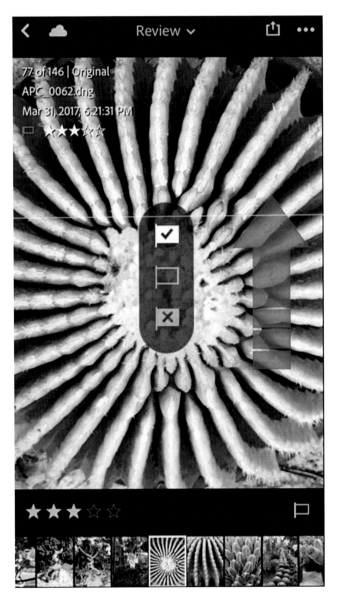

Figure 5-2. *Swipe up or down on the right side of the photo to add a rating*

Additionally, you can organize photos by giving them titles, captions, and copyright information using the Info section.

Once the photos are rated, you can display them in the Lightroom app library organized by rating. Follow these steps:

1. Open the Lightroom app library.

2. Tap the Lightroom Photos drop-down list.

3. Select the Segmented tab. This allows you to filter the photos based on their ratings, flagging, likes, and comments, as shown in Figure 5-3.

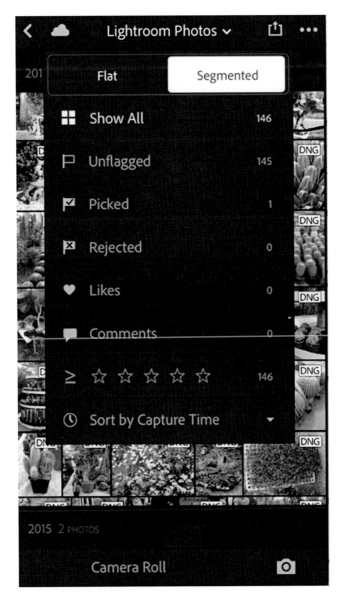

Figure 5-3. *Tap Lightroom Photos to access the filter options*

4. Set the flag to Picked to display only the photos that are rated with five stars, as shown in Figure 5-4.

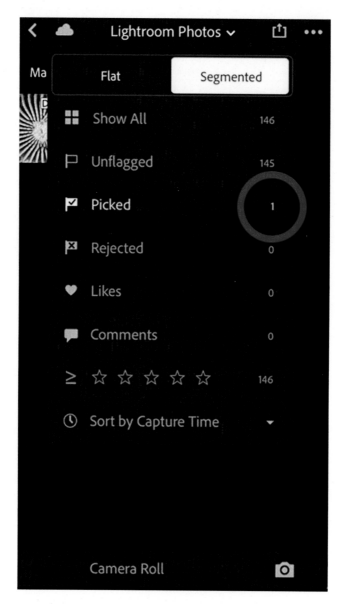

Figure 5-4. *Tapping a filter option displays only the images that meet this criterion*

5. Remove the rating filter to display all the photos again.

Work with Collections

Adobe Lightroom also allows you to organize the photos into collections. For instance, you can group all the related photos in one easily accessed collection. When you open the Lightroom app, can view either all the collections or the specific collection. If you can't see all the collections, simply tap the Back arrow at the top of the screen to get back to the Collections view.

You can create a new collection by tapping the plus icon at the top right of the screen. Enter the name of the collection and tap OK, as shown in Figure 5-5.

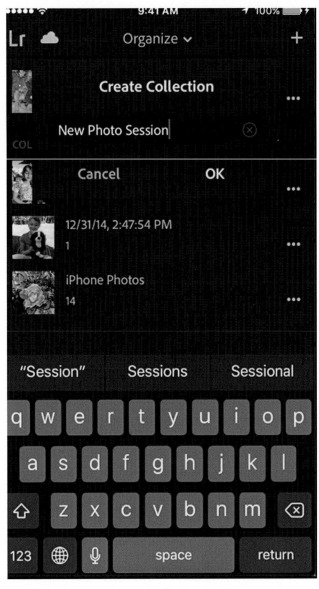

Figure 5-5. *Creating a new collection in the Lightroom app*

Also, you can add photos to a collection or apply different options to collections as follows:

1. Tap the icon on the right of the collection to select it.

2. Tap Add Photos, as shown in Figure 5-6.

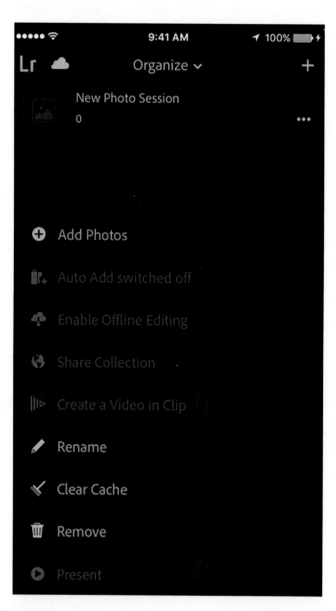

Figure 5-6. Tap Add Photos to add photos to the selected collection

3. Select the photos you want to add to the collection. From the top-right menu, you can filter a photo based on its type: Photos, Videos, or Raw.

4. Tap Add Photos to add those photos to the collection, as shown in Figure 5-7.

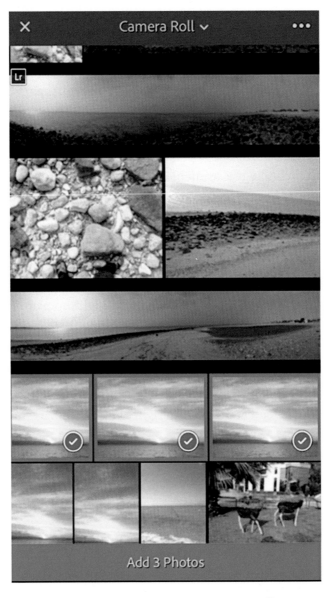

Figure 5-7. *Select multiple images to add them to the collection*

Take Raw Photos in Lightroom

The common photo formats that you probably use every day such as JPG, PNG, and GIF are called *processed formats*, which means the camera processor combines the information related to the photo, such as the colors, exposure, and white balance, with the photo's grayscale data to produce the final image. While there are a variety of applications and tools that can help you edit processed photos, the capabilities are limited because of the processing that takes place on the images.

Unlike those formats, the Camera Raw technology maintains the picture unprocessed, which means when you take the photo using your camera or iPhone, the grayscale information of the image is saved separated from the image information. This information is known as the *metadata* XML file. This technology helps you extend your editing capabilities because you can simply change the metadata of the image instead of the image itself. This means you can modify an image multiple times.

The Camera Raw technology is available in many cameras, and each brand has its own Camera Raw format. However, DNG is a universal format that works on multiple devices and with Camera Raw plug-ins. iPhone supports the Camera Raw format via the Lightroom app.

Note that Camera Raw images have a very large size; they can fill up your phone's storage space. So, try to use this feature carefully and with a selected number of images. You can activate this option only when needed. In the Lightroom app, you can take photos in DNG Camera Raw format as follows:

1. Open the Lightroom app.

2. Log in with your Adobe ID.

3. Tap the camera icon at the bottom right of the screen, as shown in Figure 5-8.

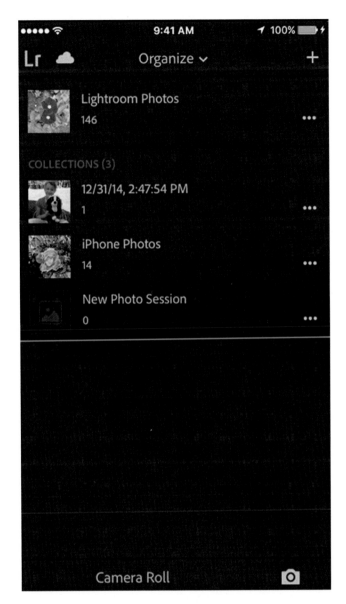

Figure 5-8. *Tap the camera icon to access the Camera app*

4. Tap File Format at the top center of the screen.

5. Drag the slider to choose between the JPG and DNG formats, as shown in Figure 5-9.

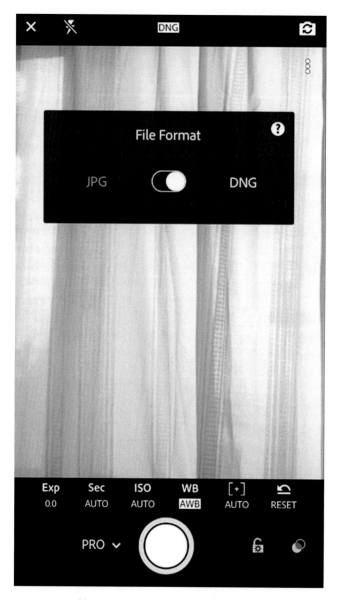

Figure 5-9. *Drag the slider to switch between JPG and DNG (Camera Raw)*

After setting up the photo format, Lightroom gives you three modes to take the photo, which are Automatic, Professional, and High Dynamic Range, as shown in Figure 5-10. The Automatic mode allows you to take quick Camera Raw photos without worrying about the different camera settings. Professional mode lets you control the image properties including the shutter speed, ISO, and aperture. When choosing the third method, High Dynamic Range (HDR), you can tap and hold to have the phone take photos with multiple exposure values. Then, the phone processes all the photos to create an HDR photo effect automatically.

Figure 5-10. *The Professional photography mode in the Lightroom app*

In the following steps, you will explore how to take a Camera Raw photo using the Professional mode:

1. From the options on the left of the shutter button, set the mode to Professional.

2. Use the Exposure value to change how the photo exposes to light. A higher exposure value means more light in the photo, while a lower value means a low-light photo.

3. The shutter speed (Sec) lets you determine the speed of opening and closing the camera shutter. A high shutter speed means less light and a more stable shot; it is suitable for moving shots such as kids playing. A low shutter speed means more light and less stability; it is suitable for taking still photos or nature photos. However, it is advised that you to use a tripod to ensure a steady shot. If you are not sure about the best shutter speed for you, you can just set it to Auto by dragging the slider to the far left.

4. The ISO value determines the sensitivity for the light. High ISO means high sensitivity to light; however, it can cause "noise" in the image. Therefore, it is advised not to use a very high ISO value.

5. The white balance (WB) lets you choose between different white balances such as Tungsten, Fluorescent, Daylight, and Cloudy.

6. The Focus value lets you determine the field of focus in the photo. A low value represents a shallow depth of field. It displays the near objects in focus while the far objects look blurry. A high value creates a clear scene without my blurry effects.

Integrate Files with Lightroom on the Desktop

One of the major advantages of using the Lightroom app on your iPhone to take and edit photos is the ability to integrate your photos with the desktop version of the application. Through this integration, you can take photos using your phone, edit them, and then transfer them to the desktop app for more advanced modifications and editing features. There are two main ways to integrate photos between the Lightroom app on the iPhone and the desktop version: by using cloud storage and by importing the photos from the mobile app.

Integrate Photos Through the Cloud

This method allows you to sync between the Lightroom app on your phone and the desktop application through an Adobe Creative Cloud membership. If you are doing photography projects and photo editing, you can sign up for the photography Creative Cloud membership, which allows you to use the photo-editing desktop applications such as Lightroom and Photoshop in addition to the mobile apps.

Once your phone's photos are synced, they will be available from Adobe Lightroom on the desktop, including all the modifications applied to the images.

1. Open the Lightroom app on your phone, and log in with your Adobe ID.

2. From the Lightroom library, tap the cloud icon at the top left. This will sync all the photos through the cloud.

3. Tap one of the photos and edit it using the different Lightroom features. After modifying the photo, tap the cloud icon at the top left to sync the change with the cloud, as shown in Figure 5-11.

Figure 5-11. *Tap the cloud icon to sync the image modifications*

4. Now, go to the Lightroom application on your computer.

5. On the left side, click the iPhone. Click Imported Photos to display the synced photos.

6. Select the photo you edited on your phone, as shown in Figure 5-12.

Figure 5-12. *You can display the synced photos in Adobe Lightroom on a computer*

7. Click the Develop tab at the top right of the screen to enter editing mode.

8. In the right-side panel, select the Radial Filter icon, as shown in Figure 5-13.

Figure 5-13. *Select the Radial Filter icon in Lightroom on your computer*

9. Drag to create a radial filter over the image.

10. Set Saturation to -100 to remove the color from the edges of the
 photo, as shown in Figure 5-14.

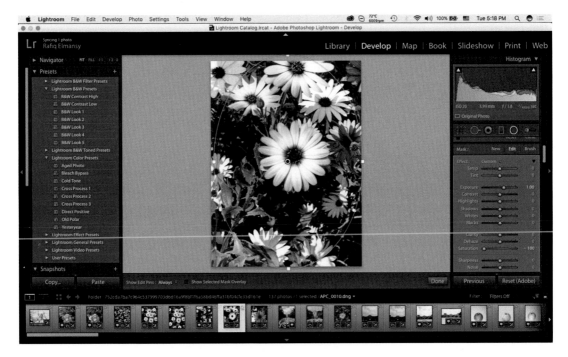

Figure 5-14. *Apply a radial filter while reducing the image's edge saturation*

Note To use the sync feature, you need to have Adobe Lightroom CC or a later version installed on your computer.

Import Photos from Your iPhone

Sometimes you have photos that are saved in your phone's photo albums rather than the Lightroom app itself. These photos may be taken or modified using other mobile apps. In this case, you can import the photos directly to the Lightroom application on your computer by linking the photo and the computer using a USB cable. This method is also helpful if you're not subscribed to any of the Adobe Creative Cloud memberships because this feature can work with the free Adobe ID without the need to pay for any membership packages.

1. From the Adobe Lightroom application on a computer, choose
 File ➤ Import Photos and Videos.

2. Set the From source to iPhone, as shown in Figure 5-15.

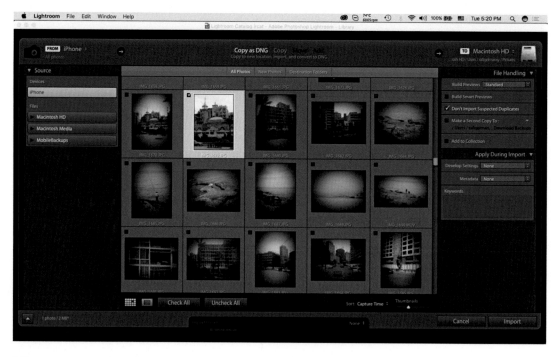

Figure 5-15. *Importing images from the iPhone photo library*

3. Click All Photos to deselect it.

4. Select the photos you want to import.

The photos will be imported and displayed in the library. They are also saved in the default location on your computer. You can change the location where the imported photos are saved on the computer from the Preferences dialog box (Lightroom ➤ Preferences on macOS or Edit ➤ Preferences on Windows), as shown in Figure 5-16.

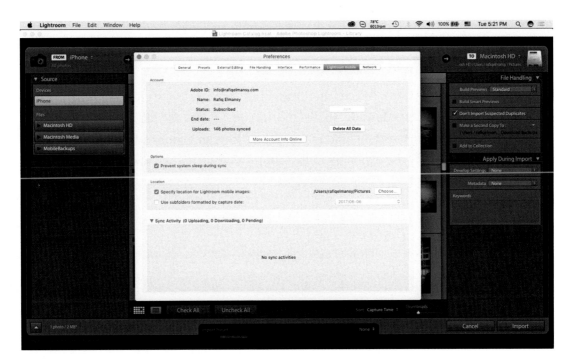

Figure 5-16. *Changing the import folder in the Preferences dialog box*

Use Other Raw Photo Apps

Adobe Lightroom is not the only mobile app that allows you to take Camera Raw photos. The RAW app by 500px is a free application that you can download and use to take Raw photos; you can also modify these photos and upload them to your profile on www.500px.com, a social network for photographers to showcase their photography work. You can save the photos in your iPhone's Camera Roll for further modifications. To take Raw photos using the RAW app, you can follow these steps:

1. Install the RAW app from the App Store.

2. Log in using your 500px free account.

3. Drag the left slider next to the shutter button to the right side to activate advanced mode. In this mode, you can use the left slider to control the depth of field in the photo. The right slider allows you to modify the exposure of the photo, as shown in Figure 5-17.

Figure 5-17. *Taking photos using the RAW app*

4. Once a photo is taken, drag from the right to the left to enter the
 photo library, as shown in Figure 5-18.

Figure 5-18. *Selecting photos from the RAW app library*

5. Select the photo to modify it and use the bottom icons to crop, adjust, or apply presets, as shown in Figure 5-19.

Figure 5-19. *Editing Raw photos in the RAW app*

6. Once you are done with the modifications, tap the right icon at the top right to apply the changes.

Summary

You can extend your iPhone photography skills by taking Camera Raw photos, which are unprocessed images that maximize your ability to modify the photos after taking them. This can help you to create professional photos even if the circumstances you took the photos in were not helpful (such as bad light conditions). You can also extend your photography skills by integrating your mobile apps with their desktop photography versions to be able to reach more advanced features.

Adobe Lightroom is one of the top photography and photo-editing applications for photographers. It can help you take photos using your iPhone and then integrate them with its desktop version so you can apply more accurate and intensive photo-editing techniques. This can help you to produce professional photo results.

In addition to the Lightroom app, there are other applications that can help you to take Camera Raw images such as the RAW app provided by 500px. It allows you to take Raw photos, modify them, and save them on the iPhone in the Camera Raw format. You can also share the photos through your profile on the 500px web site.

Practice Exercise

For this exercise, take some photos using the Camera Raw technology via the Lightroom app or any Raw-supporting app. Then use this app to modify your photos, share them to the Facebook group, and discuss the results with your peers.

Integrating Your Photos with Adobe Photoshop on the Desktop

As you learned in the previous chapter, integrating your photo-editing tasks between your iPhone and your computer helps you create even better photos. You can use the computer's full-featured photo-editing applications such as Photoshop and Lightroom to enhance and manipulate your photos. When you send the photo from your Adobe mobile app to the desktop application, you can preserve the layers, effects, and adjustments.

Prepare Your iPhone for Integration

To integrate between the Adobe apps on your iPhone and the desktop versions, you need to be signed in to the Creative Cloud from the app. This will allow you to share files with your computer through the Creative Cloud. In fact, you can integrate all the Adobe mobile apps through the Creative Cloud. These steps show you how to connect to the cloud from the Lightroom app:

1. Open the Adobe Lightroom app. If you are not signed in, you will see a "Sign in" button; tap it.

2. On the "Sign in" screen, enter your Adobe ID username and password, and tap "Sign in" (see Figure 6-1).

© Rafiq Elmansy 2018
R. Elmansy, *Developing Professional iPhone Photography*, https://doi.org/10.1007/978-1-4842-3186-9_6

Figure 6-1. *Sign in to enter Creative Cloud*

3. Click the Lightroom logo icon at the top left to open the app menu
 (see Figure 6-2).

Figure 6-2. *Creative Cloud sync settings*

4. Activate Sync Only Over Wi-Fi to avoid draining your mobile Internet data and keep the syncing only when you have access to a Wi-Fi connection.

5. Deactivate Prevent from Sleep to allow your phone to go to sleep while doing the sync. This can save the battery.

6. Activate Load Full Resolution to use the highest resolution possible for photos.

7. Activate Auto Add Photos to sync photos automatically.

8. Deactivate Auto Add Videos to avoid syncing videos.

To review the synced documents, you need the Adobe Creative Cloud app installed on both your iPhone and your computer. When you log into your cloud app from your iPhone, you will be able to check the synced documents based on their type (see Figure 6-3).

***Figure 6-3.** Viewing the synced documents from the Creative Cloud console*

On your desktop computer, the Creative Cloud console allows you to view the cloud documents, find applications to download, find fonts, and see your follower updates (Community). You can also access the documents you saved from your iPhone to the cloud storage as follows:

1. Open the Creative Cloud console. If it is not downloaded, you can download it from Adobe.com.

2. Click the Assets tab and then choose Files. Here, you can learn about your storage, the type of subscription (either free or paid), and the file update status.

3. Click Open Folder to open the local folder where you can find the synced files from your iPhone (see Figure 6-4).

Figure 6-4. *Setting up the Lightroom options from the main menu*

Integrate Files with Desktop Photoshop

Once you log into the iPhone Adobe apps and prepare to sync photos between the app and desktop applications, you can send the files from these apps to the desktop version, where they are synced in the cloud. Then the files will be opened automatically in the associated application. In the following example, you will send a document from the Photoshop Fix app to Photoshop on the desktop and explore how the sent file has preserved its structure:

1. Make sure that the Creative Cloud console app is installed on the desktop computer and that both the computer and the iPhone are connected to the Internet.

2. Open the Photoshop Fix app on the iPhone.

3. Select one of the existing projects or create a new one. Make sure that the file is optimized and doesn't have any unwanted layers to avoid slow syncing between the app and the desktop version of Photoshop (see Figure 6-5).

Figure 6-5. *One photo in Photoshop Fix*

4. Click the Share icon. You can choose to send the document to Photoshop CC, save it for the Lightroom app, or save it in the cloud storage only. Choose Send to Photoshop CC (see Figure 6-6).

Figure 6-6. *Sharing the project with Photoshop CC*

Notice that the desktop Photoshop opens with the document in it. In the Layers panel, you can check the effects and adjustments applied to the photo. If you applied any healing effects, for example, they will show up in a new layer above the original photo. This nondestructive modification can help you to edit and modify the effects even after opening them in Photoshop CC on the desktop (see Figure 6-7).

Figure 6-7. *The photo in Photoshop CC*

Complete an iPhone Photo on the Computer

Tools used: Photoshop Fix app, Photoshop CC desktop

Figure 6-8 shows the original photo I used in this example.

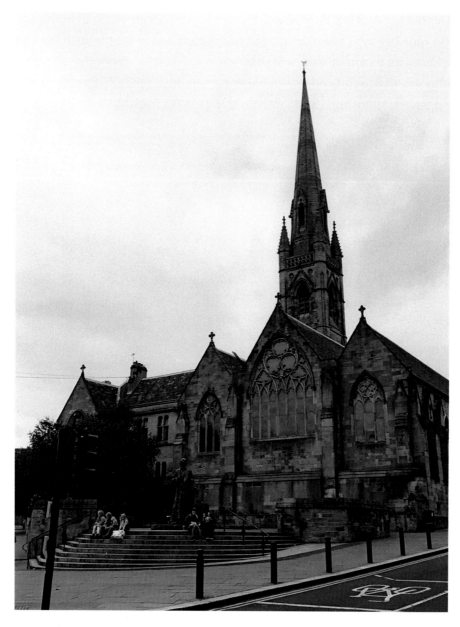

Figure 6-8. *The original photo*

Figure 6-9 shows the final results.

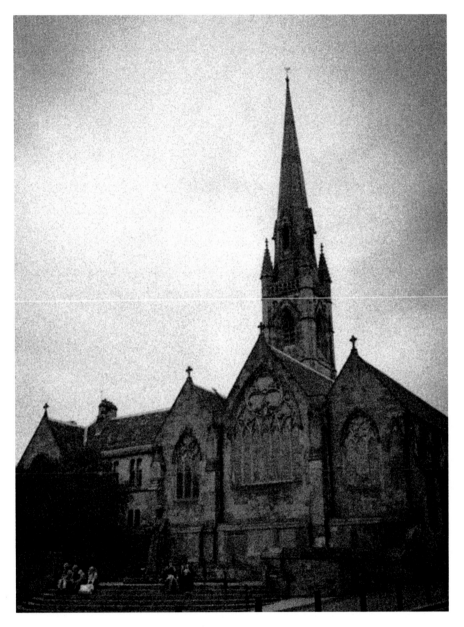

Figure 6-9. *Final result*

To practice the integration between the iPhone and your computer, I have a photo that I took of the city of Newcastle in the United Kingdom using my iPhone. I will edit this photo using the Photoshop Fix app. Then I will send it to Photoshop CC to complete the project by adding noise to the photo. This will give it an old-style effect; then I will apply a vignette to the edges of the photo. To follow along, continue reading.

Step 1: Fix a Photo on the iPhone

Here are the steps:

1. Open Photoshop Fix. Tap the plus icon to create a new project.

2. Tap On My Photo and navigate to the photo in the Camera Roll.

3. Tap the Crop icon to crop the bottom part of the photo.

4. Tap Original in the cropping options to maintain the same ratio of the photo. Drag the bottom-left edge to remove the lower part of the shot and focus on the building (see Figure 6-10).

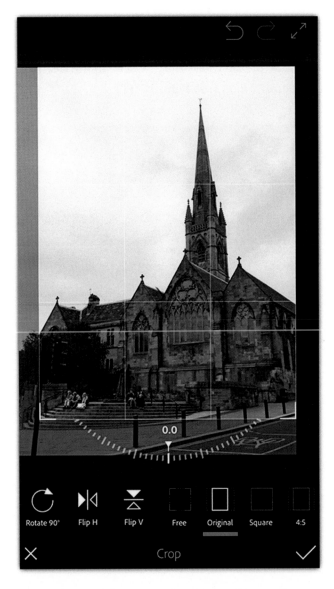

Figure 6-10. *Crop the photo to focus on the main object ad remove distractions*

5. Tap the Healing icon to remove the traffic light and the wires above the building from the shot.

6. Choose the Clone Stamp tool. Click the area of the tree next to the top part of the traffic light (see Figure 6-11).

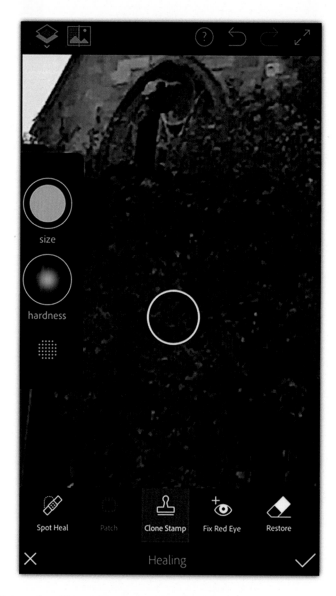

Figure 6-11. *Using the Clone Stamp to fix the photo*

7. Tap the Spot Healing tool and paint over the wires above the building to remove them; then tap Apply (see Figure 6-12).

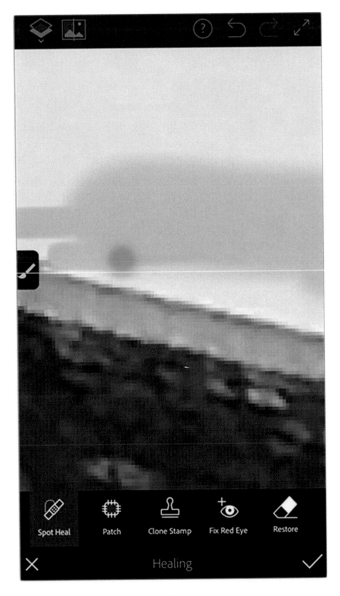

Figure 6-12. *Using the Spot Healing tool*

Step 2: Send the Document to Photoshop CC

To send the document to Photoshop CC, follow these steps:

1. Tap the Share icon in Photoshop Fix.

2. Tap Send to Photoshop CC (see Figure 6-13).

Figure 6-13. *Sending the photo to Photoshop CC*

The document is updated and sent to Photoshop CC through the Creative Cloud.

Step 3: Apply Effects in Photoshop CC

Here are the steps to apply some effects in Photoshop CC:

1. If the document didn't open automatically in Photoshop CC, click the Creative Cloud console, choose Assets ➤ Files, and click Open Folder.

2. Open the photo in Photoshop CC.

3. I would like to apply the effects on all the documents, so I will convert the layers group to a smart layer. To follow along, click the layer group at the top of the Layers panel; then choose Filter ➤ Convert to Smart Filters (see Figure 6-14).

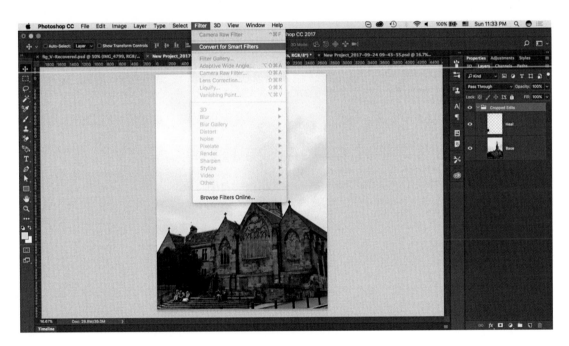

Figure 6-14. *Converting the layers to a smart object*

4. Click OK to convert the layers to a smart object.

5. In the Filter list, choose Camera Raw Filter (see Figure 6-15).

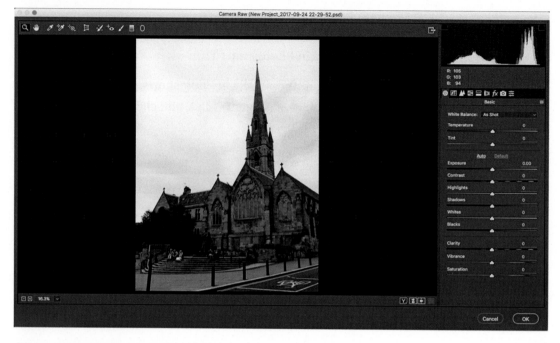

Figure 6-15. *Opening the image in Camera Raw*

6. Click the FX icon on the right side.

7. Set the Grain amount to 100, Size to 70, and Roughness to 70.

8. Set Post Crop Vignetting to -50 (see Figure 6-16).

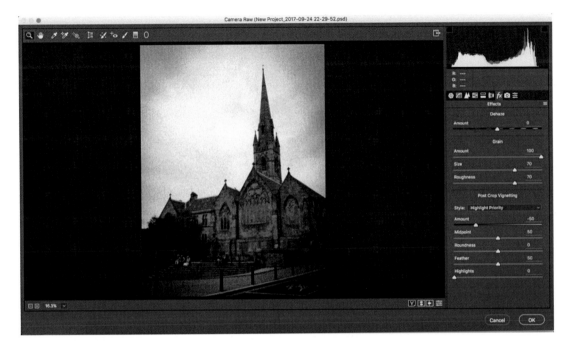

Figure 6-16. *Applying the Grain and vignetting effects on the photo*

9. Tap OK.

Summary

You can extend your iPhone photo-editing abilities by integrating your work with desktop applications such as Photoshop and Lightroom. This helps you to add even more effects and styles to your work. Furthermore, it will help you view the fine details of your editing work on a bigger screen. If you are using the Adobe mobile apps, you can easily integrate your work with the desktop applications through the Creative Cloud. You can just send the work you did in the Adobe apps on the iPhone such as Photoshop Mix to the desktop. The file will be opened on the desktop in its associated application, where you will find the layers preserved.

Practice Exercise

Start a photo-editing project that involves taking a photo and editing it in one of the Adobe mobile apps such as Lightroom or Photoshop Fix. Then, send the document to Photoshop CC and complete the work there.

CHAPTER 7

Turning Photos into Fine Art

Both photography and fine art are considered art. While photography depends on the camera to create the visual artwork, fine art uses different tools such as brushes, drawing pens, pastels, and others. Digital applications can help you to simulate the effect of the fine art tools and apply them to your photos to create what looks like a painting or drawing. There are many apps that help you create fine art effects on the iPhone, and you can even use multiple apps to improve the final result of your art piece.

The tips in this chapter show how to turn some of your iPhone photos into fine art pieces.

197

© Rafiq Elmansy 2018
R. Elmansy, *Developing Professional iPhone Photography*, https://doi.org/10.1007/978-1-4842-3186-9_7

Create Pop Artwork

Tools used: Prisma app, Lightroom app

Figure 7-1 shows the original photo that I used in this example. You can use a similar photo to follow along with the exercise.

Figure 7-1. *Original photo*

Figure 7-2 shows the final result.

Figure 7-2. *Final result*

In this example, I have a photo of some urban architecture that I want to convert to "pop" artwork. To do this, first you open a photo in the Lightroom app to modify its color to be more vibrant and contrasted. Then, you open it in the Prisma app to apply the artwork. Since there is not much control over the colors in the Prisma app, you can take the artwork back to Lightroom to modify the color combination.

Step 1: Modify the Photo Light and Contrast

To modify the photo light and contrast, follow these steps:

1. Open a photo in Lightroom.

2. Tap the Crop icon, and crop the image to focus on the main element in the shot (see Figure 7-3).

Figure 7-3. *Cropping the photo in the Lightroom app*

3. Tap the Light icon, and increase the contrast of the image.

4. Tap the Color icon, and increase the Vibrance setting by dragging the slider to the right (see Figure 7-4).

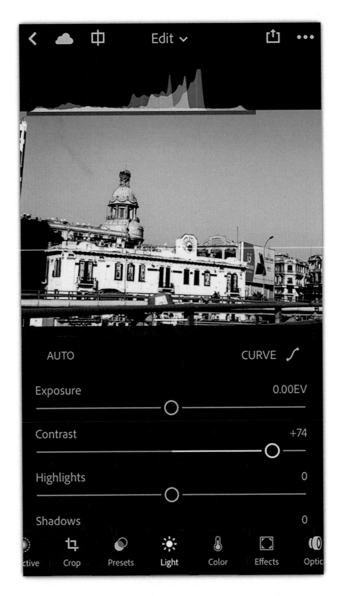

Figure 7-4. *Increasing the color vibrancy for the shot*

5. Tap the Share icon, choose Save to Camera Roll, and select the Maximum size.

Step 2: Apply the Pop Art Effect

To apply the pop art effect, follow these steps:

1. Open the Prisma app, swipe up with your finger to access the Camera Roll, and select the photo you just modified in the Lightroom app.

2. At the bottom, drag to reach the Roy effect; it is the one that can help you to convert the photo to pop art. If you need other effects, you can use any of the existing effects or tap the Store icon to buy more artistic effects (see Figure 7-5).

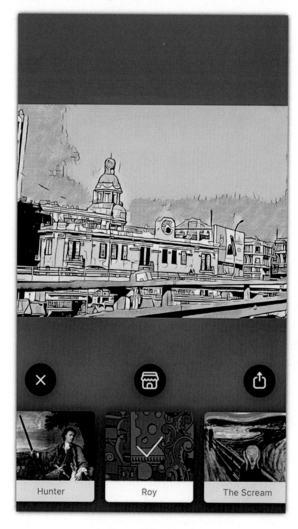

Figure 7-5. *Applying the pop art effect (Roy) in Prisma*

3. Tap the Share icon that allows you to share the photo with different social networks or save it to your iPhone.

4. Tap the Save icon at the bottom to save it to the Camera Roll.

Step 3: Change the Pop Art Color

To change the pop art color, follow these steps:

1. Open the edited image in the Lightroom app.

2. Tap the Presets icon, and select Cross Process 1 (see Figure 7-6).

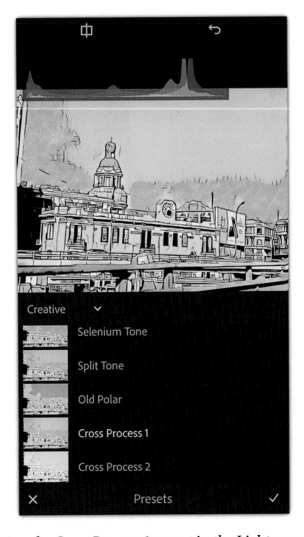

Figure 7-6. *Applying the Cross Process 1 preset in the Lightroom app*

3. Tap the Apply icon.

4. Tap the Share icon, choose Save to Camera Roll, and choose the Maximum size.

Turn Photos into Mosaic Artwork

Tools used: Photoshop Fix, Deep Art Effect, Photo Splash

Figure 7-7 shows the original photo that I used in this example.

Figure 7-7. *Original photo*

Figure 7-8 shows the final result.

Figure 7-8. *Final result*

In this tip, you will learn how to turn a photo into a mosaic or cubic artwork. Here, I used a photo that was taken during my visit to Kuwait. It shows a nice view of a marina with skyscrapers in the background. But before opening the photo in the Deep Art Effect app to create the mosaic effect, I want to fix some issues in the photo, specifically, the wire that cuts across the top right of the photo. After applying the effect, I will use the Photo Splash app to improve the final effect colors. Use a similar photo to follow along.

Step 1: Fix the Base Photograph

To fix the base photograph, follow these steps:

1. Open the photo in Photoshop Fix.

2. Tap the Healing icon, and tap Spot Heal in the bottom toolbar
 (see Figure 7-9).

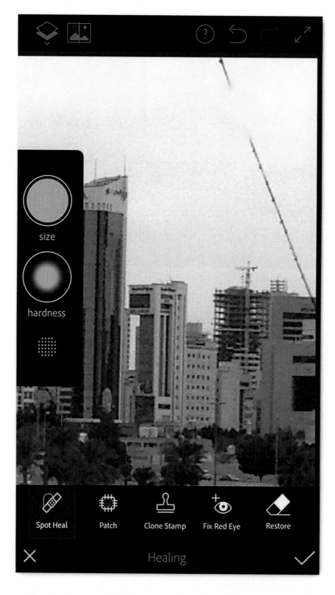

Figure 7-9. *Removing unwanted elements in the photo using the Spot
Healing tool*

3. In the left menu, set the size of the brush.

4. Paint over the area you would like to move. In this photo, I will
 paint over the wire in the sky (see Figure 7-10).

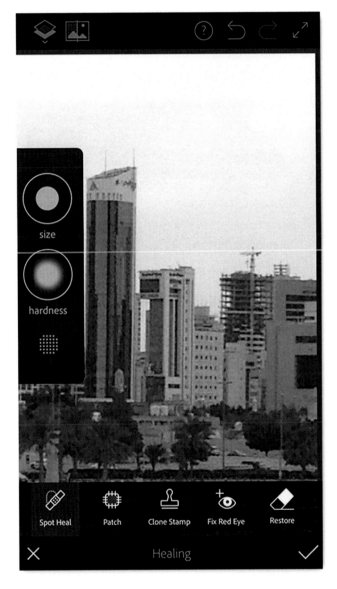

Figure 7-10. *Paint over the element you want to remove*

5. Tap the OK icon.

6. Tap the Share icon, and choose Save to Camera Roll.

Step 2: Apply the Mosaic Effect

To apply the mosaic effect, follow these steps:

1. Open the saved image in Deep Art Effect.

2. In the bottom effects, select the Mosaic 1 effect. The effect will take a few seconds to be applied to the photo.

3. Tap the Effect icon (Mosaic), and drag the slider a little to the left to reduce the intensity of the effect a little (see Figure 7-11).

Figure 7-11. *Apply the mosaic effect to the photo*

4. Tap the Save icon to save the photo to the Camera Roll.

Step 3: Improve the Mosaic Artwork Colors

To improve the mosaic artwork colors, follow these steps:

1. Open the saved photo from the previous steps in Photo Splash.

2. Tap the first icon on the left of the toolbar. Use the brush to paint over the photo to create a mask (see Figure 7-12).

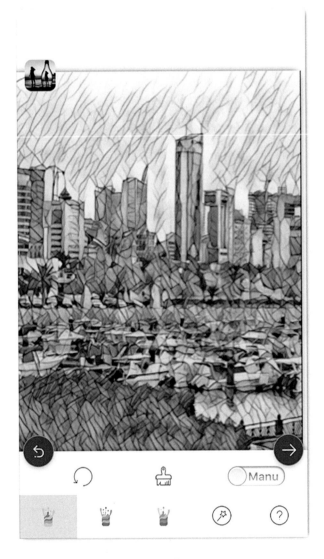

Figure 7-12. *Create a mask to apply the effect on it*

3. Tap the Effects icon, and choose the third effect from the left
 (see Figure 7-13).

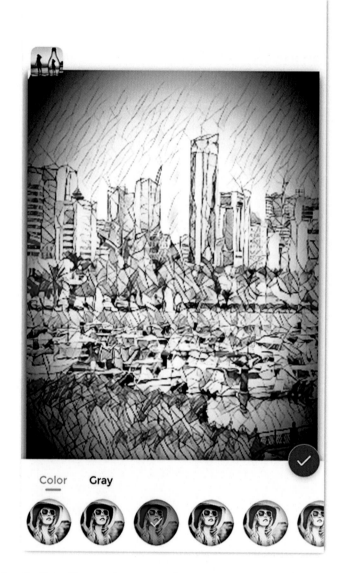

Figure 7-13. *Apply the effect to improve the mosaic artwork*

4. Tap the Next icon and then tap the Save icon to save it to the Camera Roll.

5. Select the size of the image you would like to save.

Turn Your Photo into an Oil Painting

Tools used: Lightroom app, Glaze app

Figure 7-14 shows my original photo.

Figure 7-14. *Original photo (© Radwa Khali)*

Figure 7-15 shows the final result of this tip.

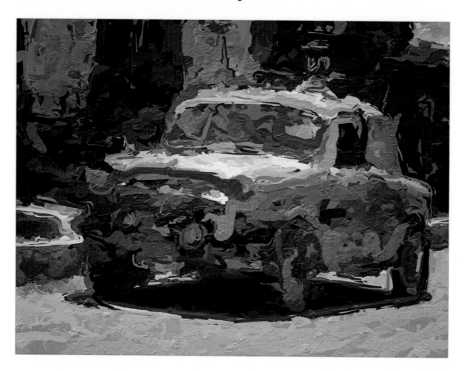

Figure 7-15. *Final results*

The oil painting has an amazing artistic effect, especially with how the brush adds the "paint" on the canvas to form the whole picture. Actually, there are many apps that can help you create artistic effects to look like oil paintings. In this tip, you will learn how to apply the oil painting effect to a photo of an old car. Then, you will apply color gradients over the photo to give it a more impressionist feel.

Specifically, I will show how to modify the photo in Lightroom to give it more vibrant colors so the applied painting effect uses the bright colors in the photo. Then, I will show how to use the Glaze app to apply the effect on the photo. After applying the effect, the photo will be returned to the Lightroom app to apply a selective mask effect on some parts of the photo to give it more artistic colors.

Step 1: Improve the Photo Colors and Contrast

To improve the photo colors and contrast, follow these steps:

1. Open the photo in the Lightroom app.

2. Tap the Color icon, and increase the Vibrance setting of the photo. Then, tap Apply at the top right.

3. Tap the Light icon, and reduce the contrast a little. This will show more details in the shot (see Figure 7-16).

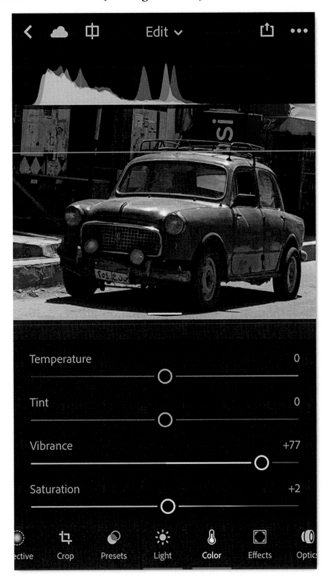

Figure 7-16. *Increase the photo vibrancy and reduce its contrast*

4. Increase the exposure a little to +0.27, reduce the highlights to -13, and increase the shadows to +25 (see Figure 7-17).

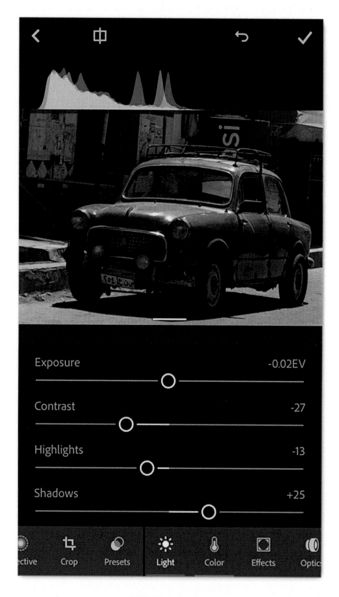

Figure 7-17. *Increase the exposure of the photo, reduce the highlights, and increase the shadows*

5. Tap the Apply icon.

6. Tap the Share icon, and save it to the Camera Roll with the maximum size.

Step 2: Apply the Oil Painting Effect

To apply the oil painting effect, follow these steps:

1. Open the edited photo from the previous steps in the Glaze app.

2. Choose an oil painting effect to apply. I used one with a realistic effect of the brush touch (see Figure 7-18).

Figure 7-18. *Apply the oil painting effect on the image*

3. Tap the Share icon and then choose Gallery to save it to your Photos folder.

Step 3: Improve the Painting Colors

To improve the painting colors, follow these steps:

1. Open the photo from the previous apps in the Lightroom app again.

2. Tap the Selective icon and then choose the Linear mask from the left side of the screen.

3. Drag to create a mask over the lower part of the photo. You can use the square in the middle of the mask to change its location (see Figure 7-19).

Figure 7-19. *Apply a selective adjustment on the photo lower part*

4. Tap the Color spectrum and drag the point to the red side to add a red hue to the masked part of the photo (see Figure 7-20).

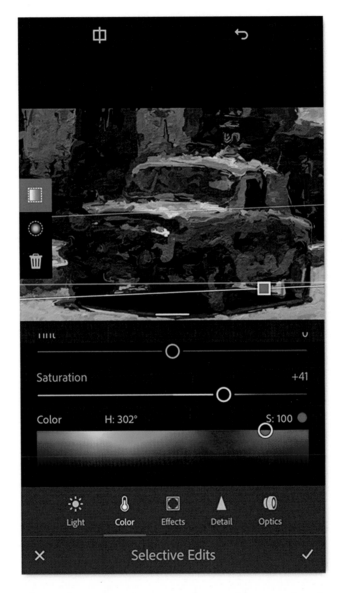

Figure 7-20. *Use the Color spectrum to apply a red hue to the photo's lower part*

5. Increase Saturation to +41 and tap the Apply icon.

6. Tap the Selective icon again to apply another adjustment mask on the upper part of the photo.

7. Tap the Linear icon on the left side.

8. Drag to create a linear mask on the top part of the photo.

9. Tap the Color icon and use the Color spectrum to add a green color to the top part of the shot (see Figure 7-21).

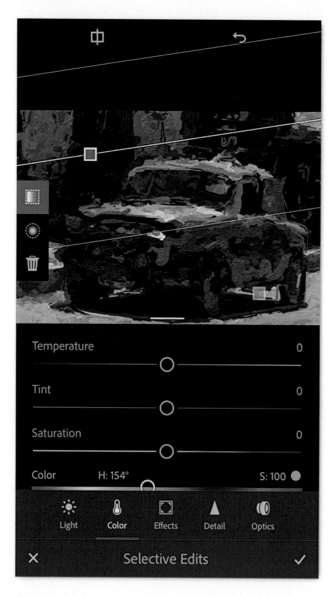

Figure 7-21. *Apply green hue to the upper part of the photo*

10. Tap the Apply icon.

11. Tap the Selective icon again, and this time apply a Radial mask to the center of the photo.

12. Tap the Light icon, and increase the exposure to +1.12 (see Figure 7-22).

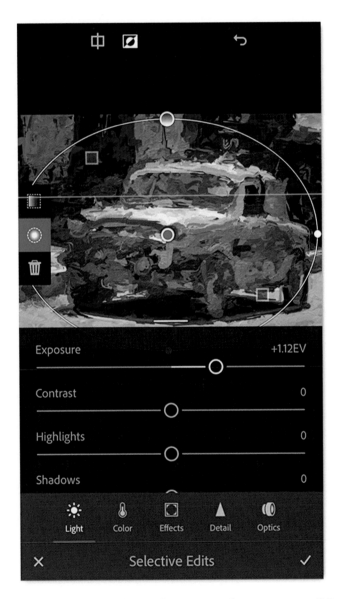

Figure 7-22. *Apply a Radial mask, and increase the exposure of the center of the image*

13. Tap the Apply icon. Then tap the Apply icon on the top-right side of the screen to add the image to the library.

14. Open it again, tap the Share icon, and choose Save to Camera Roll. Set the size to Maximum to save the artwork in your Photos library.

Add a Foggy Winter to Your Photo

Tools used: Tadaa app, Repix app

In this example, I wanted to convert a photo into a hyper-realistic painting. So, I picked a photo that I took in Paris a few years ago with my iPhone and will show how to add a foggy effect to it. I used the Tadaa app or any app that can create blur effect to add the fog to the window. Then, I used the Repix app to add small water drops on the window. The final effect should seem like you are looking at a building through a window that is covered by fog and mist drops.

Figure 7-23 shows the original photo that I started with.

Figure 7-23. *Original photo (© Rafiq Elmansy)*

Figure 7-24 shows the final photo.

Figure 7-24. *Final results*

Step 1: Add Fog to a Window

To add the fog to the window, follow these steps:

1. Open the photo in the Tadaa app.

2. Slide the toolbar to the left to reveal the Blur icon; tap it.

3. Set the blur type to All and set the blur to 30 (see Figure 7-25).

Figure 7-25. *Apply the blur effect on the photo*

4. Tap the Apply icon, and save the photo in the Camera Roll.

Step 2: Apply the Water Drops

To apply the water drops, follow these steps:

1. Open the photo in the Repix app.

2. From the tool, tap the Rain Drops pen once to activate the medium effect. Paint over the whole photo to add small mist drops.

3. Tap again on the pen to switch to the larger drops. Paint over the edges of the photo to add large water drops to the edges and keep the middle clear to display the building partly (see Figure 7-26).

Figure 7-26. *Apply the rain drops*

Step 3: Improve a Photo's Light and Color

To improve the photo light and color, follow these steps:

1. Tap the Adjustment icon. Set Brightness and Contrast to -40, Saturation to -25, Vibrance to -10, and Temperature to -15. This will reduce the light in the photo and give it a cooler winter effect (see Figure 7-27).

Figure 7-27. *Improve the effect by adjusting the color, light, and temperature*

2. Tap the Apply icon to save the photo in the Camera Roll.

Summary

Fine art has a special look, especially with the brush touches and expressive colors. You can easily convert your photo into a piece of artwork by applying different effects to look like oil painting, watercolor, and others. All you need to do is to find the proper app that can help simulate the touch of the brush or the effect you want to achieve. Apps such as Deep Art Effect, Photo Splash, and Glaze can help you turn your photos into fine art pieces. Using techniques from more than one app can produce even more interesting results. In these tips, I depended on the Lightroom app to adjust the color and light in the photos and Photoshop Fix to remove the unwanted elements in the shot before applying any effect.

Practice Exercise

To practice the tips in this chapter, you can use any photo of your choice that you would like to convert into fine art. Then, decide which effect you want to apply. Use the tips as a guide to reach the same effects as in this chapter and explore what other fine art results you can produce.

CHAPTER 8

Photo Manipulation Projects

In addition to editing photos on your iPhone, you can also create larger projects that involve multiple apps. The most challenging part is to come up with an idea and visualize the creative artwork that you will create on your iPhone. Then, you need to select other photos that can be merged with the original to form the final composition. The number of apps you use depends on the effect you want to create. I like to build the composition in one app such as Photoshop Mix and use other apps to apply filters and effects on the shot.

In this chapter, you will explore the workflow of merging photos together to create a mystic scene. You'll take elements from different photos and use the blending mode to mix between the colors to create your digital art.

Create a Fantasy Scene

Tools used: ???

Figures 8-1, 8-2, and 8-3 show the original photos I used in my example.

© Rafiq Elmansy 2018
R. Elmansy, *Developing Professional iPhone Photography*, https://doi.org/10.1007/978-1-4842-3186-9_8

Figure 8-1. *Original photo of kids (© Rafiq Elmansy)*

Figure 8-2. *Original sunset to add (© Rafiq Elmansy)*

Figure 8-3. *Original Earth photo to add (Source: Wikipedia)*

Figure 8-4 shows the final results.

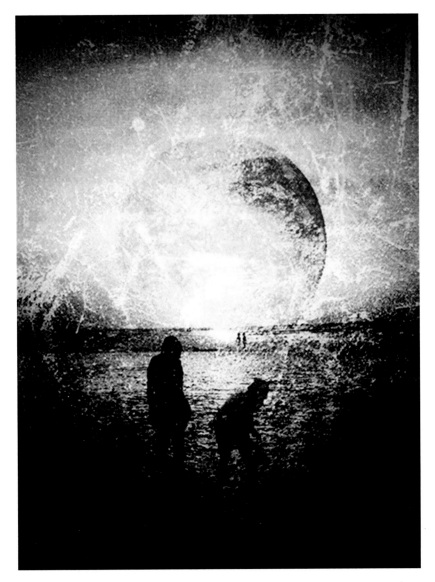

Figure 8-4. *Final result*

In this project, I will show how to merge a number of photos to create a fantasy scene of kids playing on a strange planet. So, I will start with a photo I took on my iPhone of my kids on a beach and a photo of the sunset and merge them with an Earth photo that I saved from the Internet to my iPhone. This is the only time I'm using a photo that was not taken using an iPhone because of the nature of the photo I want to create. The photo was grabbed from Wikipedia under the copyright of public domain.

Step 1: Prepare the Base Scene

To prepare the base scene, follow these steps:

1. Open the photo in Photoshop Mix.

2. Tap the plus icon to create a new project and add the first photo to the project. Currently, the main elements in the shot (the kids) are filling the screen. I want to move them to the bottom of the photo so I can add the sun to the upper part.

3. Tap the plus icon on the layers part on the right to add a new layer.

4. Tap Add New Image Layer and navigate in your Camera Roll to the extended sky photo (Figure 8-5).

Figure 8-5. *Adding the sky to the current photo*

5. Use your two fingers to resize the top photo to make it appear that the sun is extended above the first image.

6. Tap the Blend icon, and choose the Darken blending option. Then, tap the icon on the top right to apply the blending (Figure 8-6).

7. Tap the Share icon, and save the results on your iPhone.

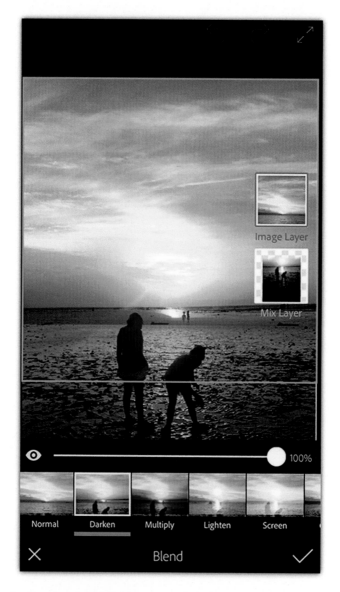

Figure 8-6. *Apply the Darken blending to the photo*

Step 2: Remove the Earth Background

To remove the Earth background, follow these steps:

1. Open the downloaded Earth photo in the Eraser app.

2. Tap the Erase icon at the bottom.

3. Tap the Erase icon.

4. Tap the Target icon, and tap the black background color in the photo. Then tap Done (Figure 8-7).

Figure 8-7. *Remove the background using the Target icon*

5. Tap the Adjust icon and then choose the Smooth tool.

6. Drag the slider to the right to increase the smoothness of the earth's edges (Figure 8-8).

7. Tap the Share icon. Set the format to PNG to generate a transparent photo and use the biggest size for the saved photo. Then tap Save to add it to the Camera Roll.

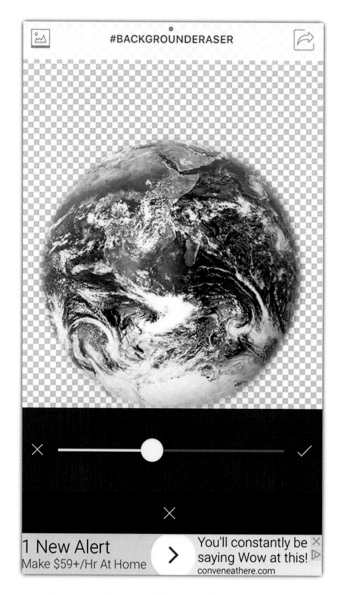

Figure 8-8. *Increase the smoothness of the earth's edges*

Step 3: Add the Earth to the Composition

To add the earth to the composition, follow these steps:

1. Open the Photofox app, and add to it the base photo from earlier in the chapter.

2. Tap the plus icon on the right to add another layer. Then, tap the Earth photo.

3. Use your two fingers to drag and resize the earth to be in place of
 the sun (Figure 8-9).

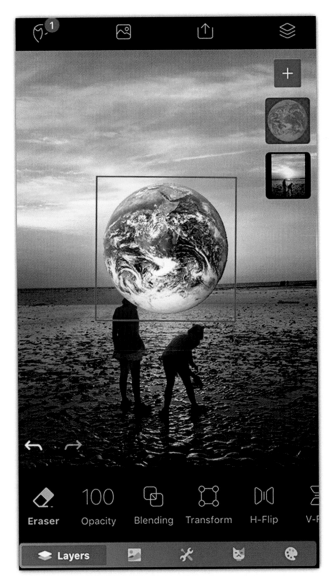

Figure 8-9. *Resizing and positioning the Earth photo in the composition*

4. From the Layers tab on the button, tap the Blending mode.

5. Tap the Earth layer, and set the blending mode to Color Burn
 (Figure 8-10).

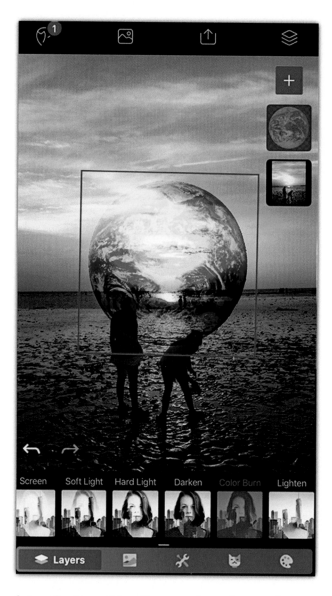

Figure 8-10. *Applying the Burn blending mode to the earth*

6. Now, I want to reduce the intensity of the earth's colors. So, I will tap the Image tab and select the Saturation. Drag the top slider to the left to reduce it (Figure 8-11).

7. Tap the Apply icon on the top right.

8. Tap the Share icon, and choose Save to Camera Roll.

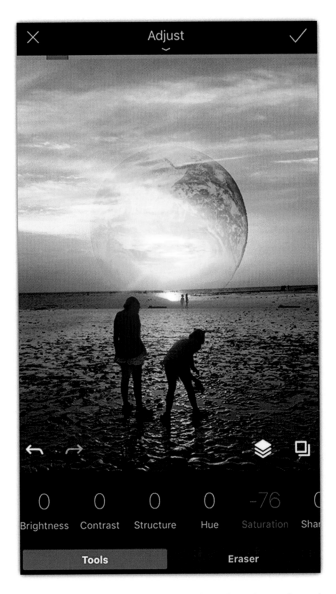

Figure 8-11. *Reduce the intensity of the earth's colors by reducing the saturation*

Step 4: Add More to the Sky

Let's change the sky a little bit to be more dramatic. I will show how to use the Fused app to add a lightning effect to the sky, using a tree photo. Follow these steps:

1. Open the Fused app. In the first photo placed on the bottom left, tap to add the photo from the previous steps as the first blending photo.

2. Tap the right side, and choose Artist Collection. I chose the Nature collection and picked a tree photo silhouette.

3. While the right photo is selected, tap the Transform icon on the left side of the toolbar.

4. Use your two fingers to flip the tree photo and resize it to the screen. Then, tap the Apply icon (Figure 8-12).

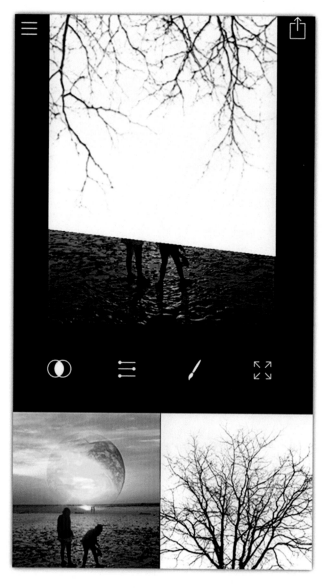

Figure 8-12. *Adding the tree effect to the sky*

5. Tap the Blend icon on the right of the toolbar, and choose the Divide mode. Then tap the Apply icon (Figure 8-13).

6. Tap the Share icon to save the photo to the Camera Roll.

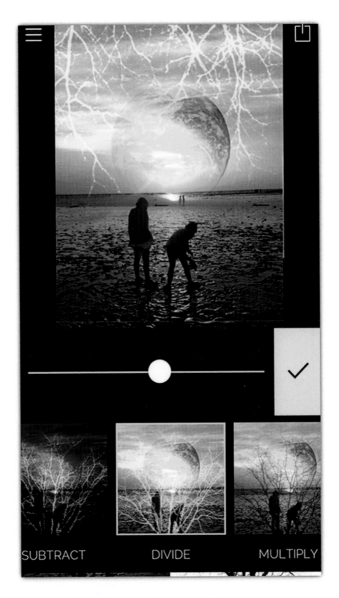

Figure 8-13. *Adding the blending mode to the photo*

Step 5: Add the Grunge Effect

Now, I will move to the Snapseed app to add the grunge effect to the photo, as follows:

1. Open the photo in the Snapseed app.

2. Tap the Tools icon, and select the Grunge filter.

3. Tap the Grunge style icon, and choose effect 5. Then tap the Apply icon (Figure 8-14).

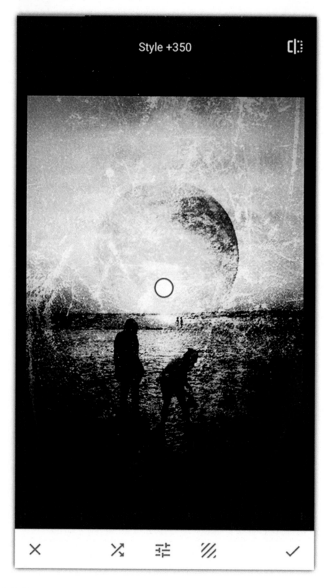

Figure 8-14. Add the Grunge effect to the photo

4. In the tools, choose the Vignette tool, drag the slider to the left, and then tap the Apply icon (Figure 8-15).

5. Tap the Share icon, and save the final result to your Camera Roll.

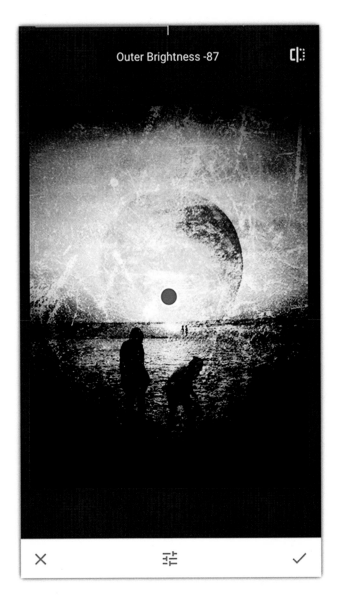

Figure 8-15. *Add a vignette effect to create the final result*

Build a Pharaonic Composition

Tools used: Adobe Lightroom app, Photoshop Fix, Photoshop Mix, Eraser, and Photofox
 Figures 8-16, 8-17, 8-18, and 8-19 shows the original photos I used in this example.

Figure 8-16. *Original photo of sky (© Radwa Khalil)*

Figure 8-17. *Original photo of pyramid (© Rafiq Elmansy)*

Figure 8-18. *Original photo of another pyramid (© Rafiq Elmansy)*

Figure 8-19. *Original photo of sunset (© Rafiq Elmansy)*

Figure 8-20 shows the final result.

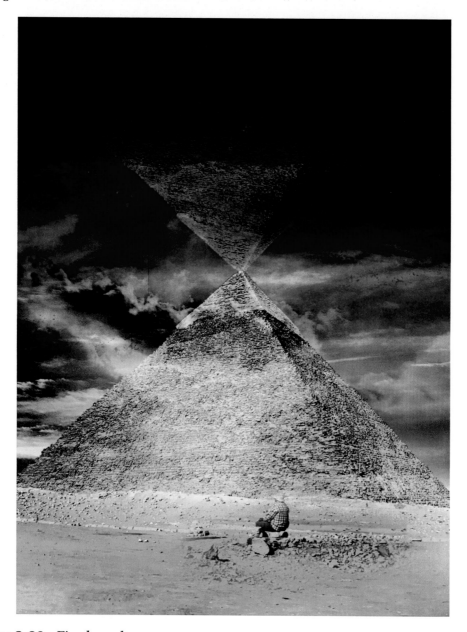

Figure 8-20. *Final result*

You can combine multiple photos to create mystic and unnatural compositions. While the photo manipulation on a computer may be done using one application such as Adobe Photoshop, on the iPhone, you are likely to use more than one app to create the effect you need.

During my trip to the pyramids, I took some photos of the grand pyramid of Khufu. To create a mystic composition, I used three photos to build the composition. I started by improving the shot color and light and then created a duplicated one with a transparent background to represent the pyramid reflection from the sky. Then, I added a mystic blue sky to cover the shot.

Step 1: Optimize the Photo Color and Light

To optimize the photo color and light, follow these steps:

1. Open the pyramid photo in Adobe Lightroom.

2. Tap the Share icon, choose Edit In, and select Maximum available. Choose Healing in Photoshop Fix to remove the car from the photo (see Figure 8-21).

Figure 8-21. *Open the base photo in the Lightroom app*

3. In Photoshop Mix, tap the Spot Heal icon. Tap the car and unwanted objects to remove them. You can use the Clone Stamp tool to do more selective healing by copying another part of the image (see Figure 8-22).

Figure 8-22. *Use Spot Healing to remove the unwanted elements*

4. Tap the blue bar at the top to save and return to the Adobe
 Lightroom app.

5. Tap the Light icon. Increase the contrast of the photo and reduce
 the highlights and shadows.

6. Tap the Color icon to increase the Vibrance setting in the photo
 (see Figure 8-23).

7. Tap the Share icon, and save the image to your Camera Roll.

Figure 8-23. *Improve the photo color, light, and temperature*

Step 2: Remove the Sky

I want to use a more dramatic sky for the composition, so I will remove the current one using the Eraser app as follows:

1. Open the modified photo in the Eraser app.

2. Tap the Erase icon, and choose Target Area. Set Threshold to 75 and tap the sky to remove it. Then tap Done (see Figure 8-24).

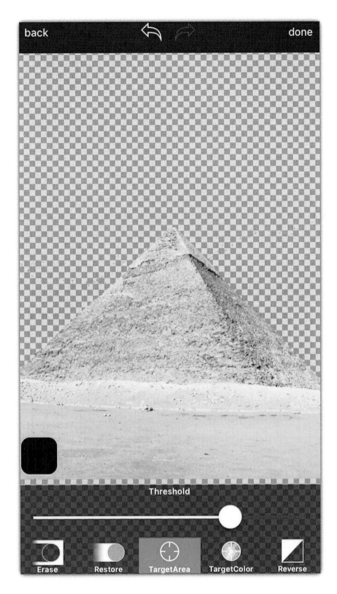

Figure 8-24. *Remove the sky background from the photo*

3. Tap the Share icon, and choose the maximum size and PNG format. Click Save to save the image to the Camera Roll.

Step 3: Build the Composition

Now, I will use Photoshop Mix to build the composition as follows:

1. Open a sky photo with a variation of colors in Photoshop Mix.

2. Tap the plus icon to add a new layer. Choose to add a new image layer. Then I navigate to the transparent pyramid photo.

3. Tap the pyramid layer to open its properties panel, and choose Duplicate.

4. With two fingers, rotate the duplicated layer to be above the first one. You can also tap the layer to open the layer options and choose Flip V (see Figure 8-25).

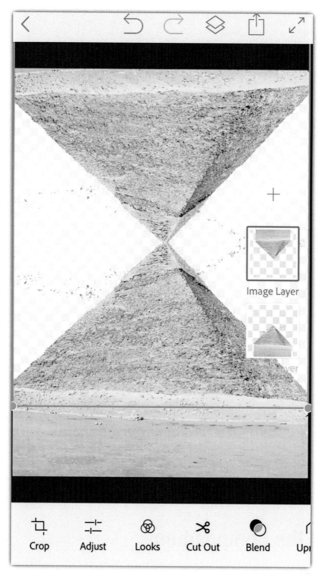

Figure 8-25. *Duplicate the pyramid layer and flip it*

5. Click the plus icon, and choose a photo for the first sky.

6. From the layers, rearrange the sky behind the pyramids.

7. Tap the top pyramid layer to open its properties panel, set Opacity to 50%, and set the blending to Overlay.

8. Tap the plus icon, and choose a photo for the setting man.

9. Tap the Cut Out icon. Select Basic to do a normal delete, make sure to tap the settings icon on the left, and choose Erase.

10. Remove the unwanted areas of the photo and keep the setting man. From the Feather icon, set up the smoothness of the edges of the image (see Figure 8-26).

11. Tap the Apply icon.

12. Tap the Share icon, and choose Camera Roll.

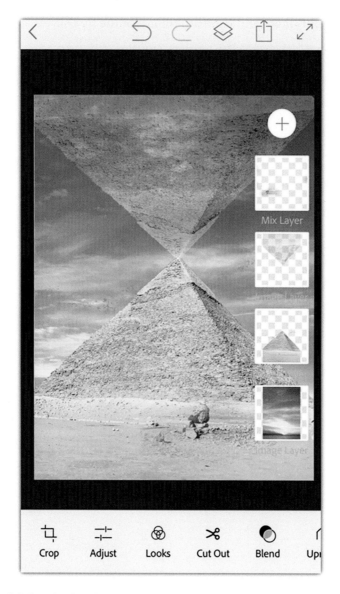

Figure 8-26. *Add the sky background*

Step 4: Add the Dramatic Sky Effect

Now, you will see how to add a second sky and use the blending mode to make it look dramatic, as follows:

1. Open the photo saved from the previous steps in the Photofox app.

2. Click the plus icon, and choose to add the image.

3. From Layers tab at the bottom, choose Blending, and set the blending of the added sky to Color Burn (see Figure 8-27).

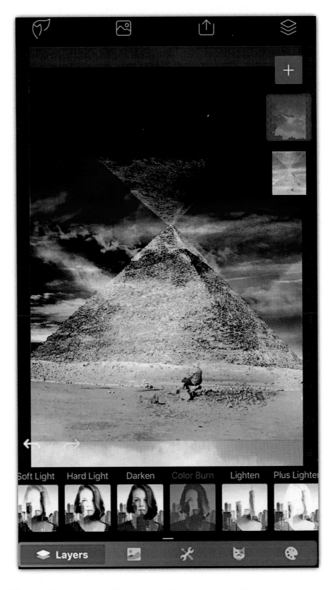

Figure 8-27. *Add the dramatic sky over the composition*

Summary

In this chapter, you explored how to combine photos to create magical scenes. The tips provided a number of examples of how to use applications to apply filters, add frames, and manipulate between photos. You can use different apps to apply the steps in this chapter to your own photos and adjust the settings according to the nature of your shot.

Practice Exercise

Start by thinking of a photo that can you can use to build a mystic or dramatic effect. Then, prepare the photos to fit with your idea. For example, remove the background and adjust the colors. Once done, you can build the composition in a layer-based application such as Photoshop Mix and Photofox.

Shooting and Editing Video

When you want to record movement and sound, you can use your iPhone to capture video footage. With the proper tools, you can even extend this capability. Similar to photography and photo editing, there are numerous apps that can help you take, edit, and apply video effects. These apps allow you to make basic video modifications (as advanced video effects require) a special software and hardware setup.

Shoot and Trim Videos

Tools used: Camera app, Photos app

In this section, you will learn about the following:

- Different types of video shooting using the Camera app

- Taking still photos while shooting video

- Trimming videos using the Photos app

The Camera app allows you to take different types of video via different modes, including normal video (Video), slow motion (Slo-Mo), and high-speed video (Time-lapse). After taking the video, you can crop out any unwanted footage at the beginning or end using the Photos app's editing features.

© Rafiq Elmansy 2018
R. Elmansy, *Developing Professional iPhone Photography*, https://doi.org/10.1007/978-1-4842-3186-9_9

Set Up the Video Quality

By default, the iPhone isn't set up to take videos with the highest quality (4K) because this can dramatically consume your storage space. Every minute of 4K video takes about 350MB of your storage, and 1080p HD video at the 60 frames per second (fps). In addition, high-quality video can slow down your editing speed comparing to editing lower-quality video, so you need to pick the video quality that best meets your needs.

1. Open Settings ➤ Photos & Camera.

2. In the Camera section, you can set the quality of the Record Video and Record Slo-Mo features. In each section, you can find a guide to the amount of storage that will be consumed with each one minute of recording (see Figure 9-1).

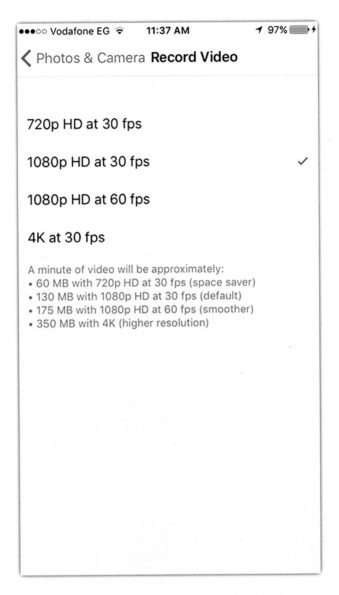

Figure 9-1. *Setting up the video recording quality in the Photos & Camera settings*

Take Still Photos While Shooting Videos

Sometimes you want to take a still photo of a scene while you are shooting video footage. This feature is available in two modes: Video and Slo-Mo.

1. Open the Camera app, and select the Video mode.

2. Press the home button or one of the volume keys to start the video.

3. Tap the white button on the top left of the screen to take a still photo while shooting your video (see Figure 9-2).

4. Press the home button again to stop the recording.

5. Tap the preview next to the home button to preview the video and still photos.

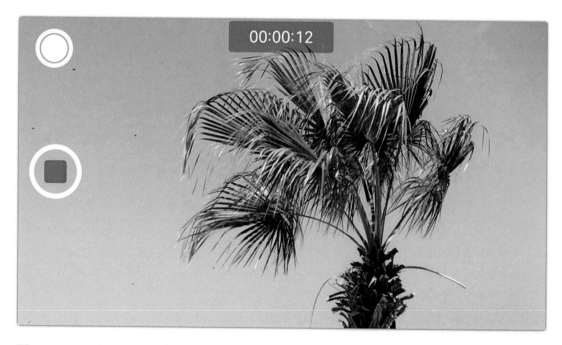

Figure 9-2. You can take still photos while shooting video by tapping the white button at the top left of the screen

Edit Footage in the Photos App

Your videos are saved in the Video album in your Photos app. You can tap a video to play the video and trim the video at the beginning or end as follows:

1. Open the video in the Photos app.

2. Tap the Adjust icon to enter video-editing mode.

3. Drag the right and left arrows to trim the video.

4. Tap Done, and choose to apply changes to the original video or create a new one with the changes applied (see Figure 9-3).

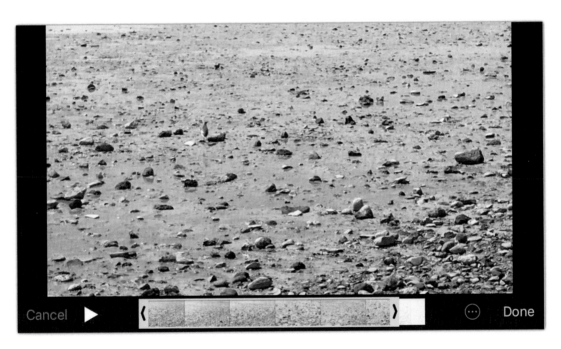

Figure 9-3. *Trimming videos using the Photos app*

Create a Hyperlapse Video

Tools used: OSnap

In this section, you will learn about the following:

- Creating a hyperlapse project

- Shooting a hyperlapse video

- Applying soundtracks to video

Hyperlapse is a time-lapse technique that lets you create video frames by taking a single photo and organizing them together to create a motion sequence. While you can create time-lapse video using the Camera app by switching to the Time-lapse mode, you don't have control over the speed of the motion or the frames in it. Using hyperlapse apps such as OSnap, you can convert a sequence of photos to a hyperlapse or time-lapse video. Then, you can have control over the speed of the video and the frames included in it.

Step 1: Create a Hyperlapse Project

To create a hyperlapse project, follow these steps:

1. Open the Osnap app, tap the plus icon, and choose New Project.

2. In the New Project dialog box, set up the project name, the orientation, and the camera. Then tap Create (see Figure 9-4).

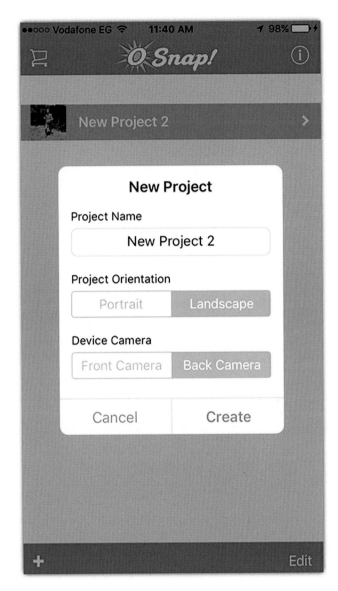

Figure 9-4. Creating a new hyperlapse project in the OSnap app

3. Tap Start Shooting or select Adjust Settings to set more of the
 project options.

Once the Camera app opens, you can tap the shutter button multiple
times to take the photos that will be used in the video (see Figure 9-5).

Figure 9-5. *Tap the shutter button multiple times to take a sequence of photos for
the hyperlapse effect*

4. Once done, tap the Back button to return to the Projects page. Then click the project.

5. Tap Play to preview the video or Shoot to add more frames to it (see Figure 9-6).

Figure 9-6. *Tap the Back button to return to the project page*

Step 2: Add Music to the Video

To add music to the video, follow these steps:

1. Tap the Music icon to open the iPhone music library (see Figure 9-7).

2. In the iPhone music library, select the video and tap the plus icon to add the video. You can also select the mic icon record a custom voice.

Figure 9-7. *Adding audio to the project from the local library*

Step 3: Modify the Animation Frames

To modify the animation frames, follow these steps:

1. Tap the Frames icon to display the frames in the video (see Figure 9-8).

Figure 9-8. *Displaying the frames used in the hyperlapse animation*

2. Tap the Edit icon at the top right.

3. Select the frames to remove from the footage.

4. Tap the Delete icon to remove them (see Figure 9-9).

5. Tap the top-left Back button to return to the project.

Figure 9-9. *Deleting the unwanted frames from the sequence*

Step 4: Export the Video

To export the video, follow these steps:

1. Tap the Share icon.

2. Tap Create Video to save it as a video file (also you can choose Save All Photo to Camera Roll to save the photos as sequence photos).

3. Tap Render Video (or tap Adjust the video rending options).

4. Tap Share Video, and select Camera Roll (see Figure 9-10).

Figure 9-10. *Rendering and sharing video output*

Edit and Apply Filters

Tools used: iMovie

In this section, you will learn about the following:

- Cropping parts from the middle of the video footage

- Applying transition between video sections

- Converting a video to black and white

- Applying filters to video

- Adding audio tracks to video

Although the Photos app doesn't enable you to apply modifications to the video other than removing footage at the beginning or end, there are apps that can fill this gap. You can use apps such as iMovie, Adobe Premier Clip, and others to extend your phone's video abilities. In this tip, I had a video of the Louvre Museum where there are two people in front of the camera. So, I want to remove them, apply a transition between the different parts of the video, and apply a black and white filter that makes the video look old.

Step 1: Create a Video Project

To create a video project, follow these steps:

1. Open the iMovie app, tap the plus icon to add a video project, and tap Movie to create a custom video project (see Figure 9-11).

Figure 9-11. *Creating a new project in iMovie*

2. Tap the video you want to add, and tap Select (the right icon) on the video to add it. You can choose more than one video to add to the same project.

3. Tap Create Movie (see Figure 9-12).

Figure 9-12. *Creating a video project from one or more videos*

Step 2: Cut the Unwanted Parts from the Video

To cut the unwanted parts of the video, follow these steps:

1. Drag the video timeline to reach the first area you want to remove.

2. Select the video on the timeline to display the video-editing tools.

3. Tap the Cut icon, and choose Split to make a cut before the unwanted area (see Figure 9-13).

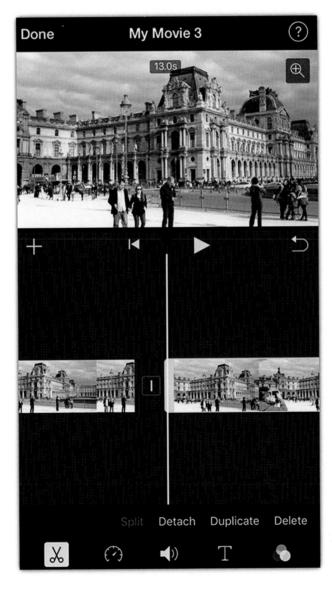

Figure 9-13. *Splitting the video on a specific point*

4. Drag the video to the area after the unwanted area, and tap Split again.

5. Select the unwanted area, and tap Delete (see Figure 9-14).

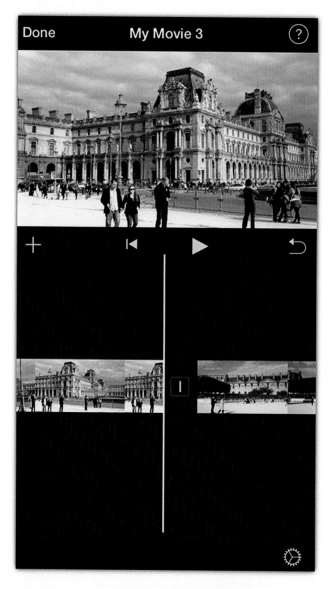

Figure 9-14. *Deleting the unwanted part of the video*

6. Now, you need to create a transition in place of the unwanted area to build a smooth transition between the video before and after the cut part. Tap the small icon between the two segments and select a transition. For example, tap Fade (see Figure 9-15).

7. Repeat these steps for all the unwanted parts of the video.

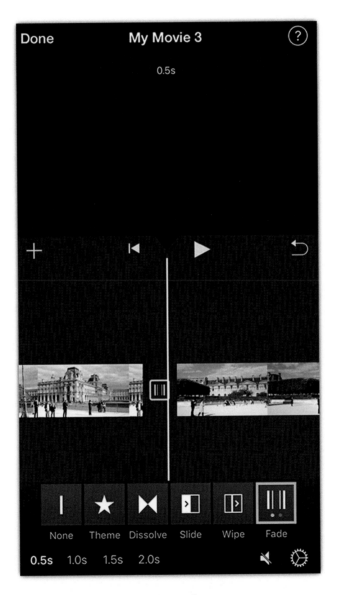

Figure 9-15. *Applying a transition to the video segments*

Step 3: Convert the Video to Black and White

To convert the video to black and white, follow these steps:

1. Drag the video to its beginning at the far left.

2. Tap the Settings icon at the bottom right of the screen.

3. In the Filters list, choose Silent Era.

4. Activate "Fade in from black" and "Fade out to black" (see Figure 9-16).

5. Tap Done.

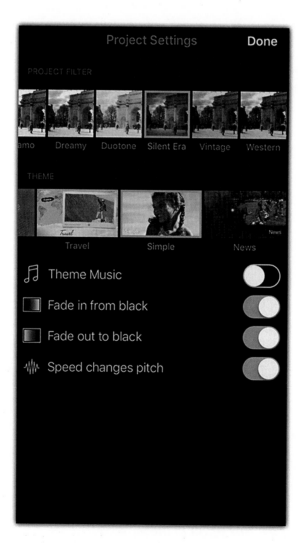

Figure 9-16. *Applying a global filter to the video project*

Step 4: Add an Audio Track to a Video

To add the audio track to the video, follow these steps:

1. Before adding the audio track, you can remove the existing video sound. While the video track is selected on the timeline, tap the Audio icon, and drag the slider to the far left (see Figure 9-17).

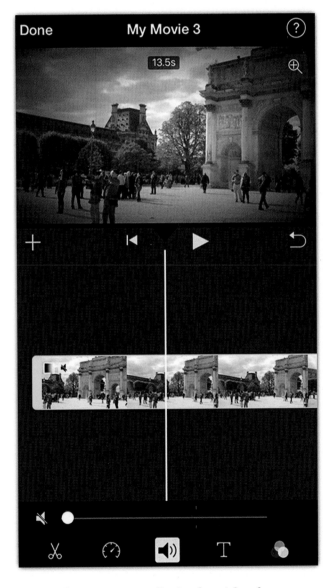

Figure 9-17. *Removing the current audio in the video footage*

2. Tap the plus icon at the top left of the timeline, select the audio track, and tap Use.

3. Select the audio track on the timeline, choose its proper volume, and tap Fade to make it fade in and out with the video (see Figure 9-18).

Figure 9-18. *Adding an audio track to the video from the library*

Step 5: Export a Project as a Video

To export a project as video, follow these steps:

1. Once done editing the video, tap Done at the top left of the screen.

2. Tap the Share icon, and choose Save Video.

3. Choose the video quality you want to use. The video will be exported to your photo library (see Figure 9-19).

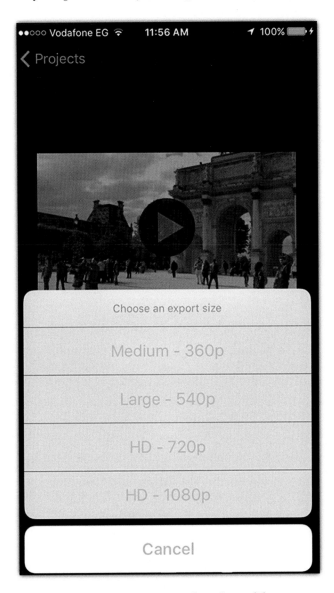

Figure 9-19. *Exporting the video project to the photo library*

Create a 1980s TV Video Effect

Tools used: Clipper app

You will learn about the following:

- Combining multiple videos

- Adding audio tracks to videos

- Applying an old style TV effect

Converting videos to look like they're old is a fun way to create nostalgic videos. In this tip, I used a video of my kids playing on the beach to apply an old 1980s TV look. I used the Clipper app to apply the effect and chose some nice soft background music for it. In these steps, I used one video, but you can add a sequence of videos to give them all the same style.

Step 1: Combine Video Footage and Audio

To add video footage and audio, follow these steps:

1. Open the Clipper app, and check the videos you want to add to your project.

2. Tap the Add icon at the top right (see Figure 9-20).

Figure 9-20. *Adding video to the project*

3. After adding the video, you can tap the icon next to the video to add more videos to the project.

4. From the Audio section of the timeline, choose Pop. You can also add tracks from your library by clicking the Audio icon (see Figure 9-21).

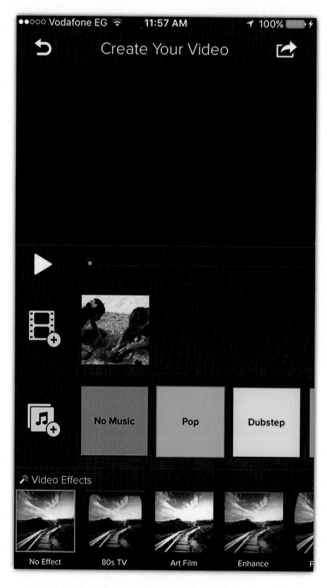

Figure 9-21. *Adding videos and audio to the project*

Step 2: Add the Video Effect and Save the Video

To add the video effect and save the video, follow these steps:

1. From the Video Effects list at the bottom of the screen, choose 80s TV to apply it to the video.

2. Preview the video by clicking the Play button at the top of the timeline.

3. Tap the Share icon at the top right of the screen. Choose to share the video on social networks or via e-mail, or save it to the Camera Roll (see Figure 9-22).

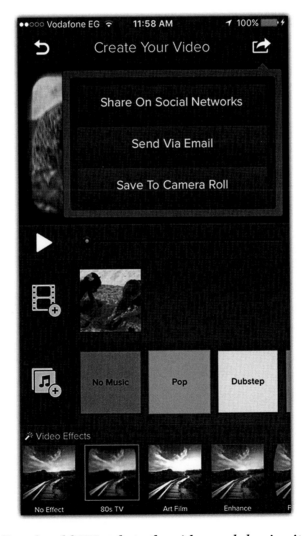

Figure 9-22. *Adding the old TV style to the video and sharing it*

Summary

You don't need an expensive video camcorder to take HD videos or complex software to edit your videos anymore. The iPhone allows you to take videos with different qualities based on your needs. Although the Photos app doesn't include many video-editing tools compared with its still photo-editing tools, such as cropping, color adjustment, and light adjustment, you can use different apps to edit your videos, apply effects, and add audio to them. While some apps give you full editing capabilities such as iMovie and Adobe Clip, other apps give you basic custom effects to apply directly to a video such as Video Toolbox. Therefore, you need to choose the app that fits well with your needs.

Practice Exercise

Think of a hyperlapse project idea, such as taking a sequence of photos of a playing kid and turn it into a time-lapse video. You can use the OSnap app for this. Then, use applications such as iMovie or Clipper to add filters and audio to the video.

CHAPTER 10

Storing Your Photos

When it comes to working with photos and video, running out of storage is one of my worst fears. It's a tough spot to be in because taking photos in the high-quality HDR or Raw format can quickly eat up the storage space of your device because of the large file sizes used. When taking photos, I usually like to take a number of shots from different angles and zoom levels, which helps when editing the photos later or deciding to use them in photo manipulation artwork. That can also take up space on the iPhone.

Unlike other mobile phones, the iPhone doesn't have the option to add a memory card to extend its storage capabilities. Therefore, you need a good plan to ensure that your device always has space for your next shots. This can be achieved by managing your storage and taking advantage of the different cloud services such as iCloud, Dropbox, Google Drive, and others. The tips in this chapter aim to explore the different hacks that you can use to manage iPhone storage.

Manage Your iPhone Storage

The first step to managing your overall storage is to make sure that you only keep what you what on your device and leave enough space for your photos. While removing unnecessary apps from your device can help you save space, this may not be enough of a solution, especially when you work with different photo-editing apps and need to have the frequently used apps installed on your device. Therefore, you can change the settings of your device to ensure that you save only the necessary documents and photos. By

287

© Rafiq Elmansy 2018
R. Elmansy, *Developing Professional iPhone Photography*, https://doi.org/10.1007/978-1-4842-3186-9_10

default, the settings on your iPhone are not configured to aggressively save the space on your device; actually, some settings should be switched as soon as you get your device to ensure that space is consumed for only the important things. The following are some of the things that you can do to help to empty the iPhone storage space for your next photography project.

Don't Duplicate Saved Photos

When taking HDR photos, you may notice that the iPhone keeps a copy of the original shot before converting it to an HDR photo. While this is meant to save your original shot, you don't need to have a duplicated version of each photo. Therefore, you can choose to stop this duplicate copy and use this setting only when needed. To control this feature, follow these steps (see Figure 10-1):

1. Open Settings ➤ Photo & Camera.

2. Scroll down to Keep Normal Photo and untick the toggle next to it.

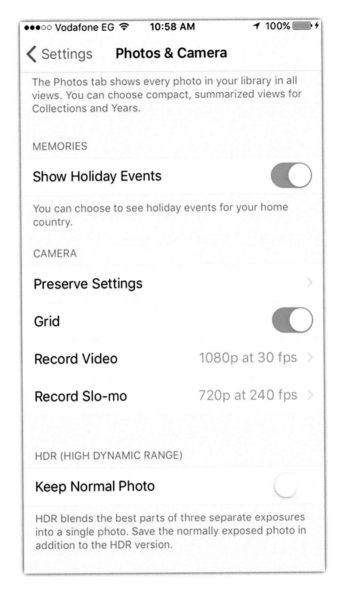

Figure 10-1. *Disable keeping normal photos when taking HDR images*

Some applications such as the Instagram have a similar feature that duplicates photos. You can switch it off by opening the Instagram app, choosing the Profile tab, and selecting the Settings icon. Then, you can deselect Save Original Photos.

Stop Storing the Text Message History

By default, iPhone stores all your sent and received messages forever. Obviously, this will consume space over time, especially if you send a lot of text message. You probably don't need those old messages, so you can limit the storage for messages to a specific amount of time and let the device delete the old ones (see Figure 10-2). Follow these steps:

1. Choose Setting ➤ Messages ➤ Messages History ➤ Keep Messages.

2. Set the time to 1 Year if you want to keep messages for that long, or set the time to 30 Days if you are fine with a shorter period.

Figure 10-2. *Removing the text message history*

Delete Downloaded Podcasts and Music

Downloaded podcasts and music can consume a lot of your iPhone's space because of their size. Sometimes you download a music track because it sounds interesting but then should remove it from your device. Keeping only the tracks that you frequently listen to can help you free some of your device space. You can do this by following these steps (see Figure 10-3):

1. Tap Settings ➤ General ➤ Storage & iCloud Usage ➤ Manage Storage.

2. Scroll down to the Music app. You can delete individual songs or all of them by swiping on All Songs.

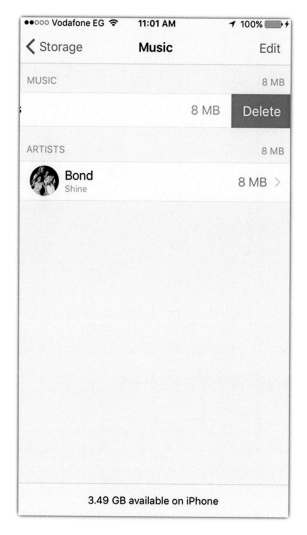

Figure 10-3. *Deleting the unwanted music*

Unlike with music, you usually listen to a podcast only once and don't need to retain each one. Therefore, it is good advice here to remove the downloaded podcasts to free some of the space on the iPhone. You can manually remove the unwanted podcasts (see Figure 10-4).

1. Tap Settings General ➤ Storage & iCloud Usage ➤ Manage Storage.

2. Scroll down to Podcasts and start deleting them one by one.

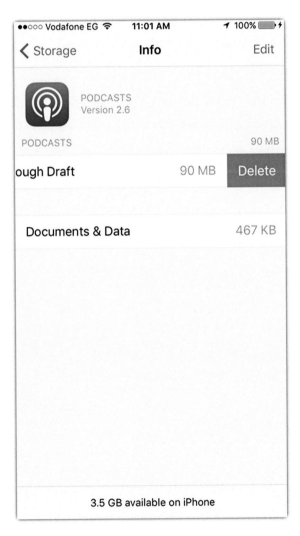

Figure 10-4. *Deleting unwanted podcasts*

Remove the Browser History and Reading List

If you use Safari on your iPhone frequently to navigate the Internet and save pages in your reading list, you may notice that the browsing history and the saved reading list cache consume part of your storage space. You can remove the Safari's browser cache by opening Settings ➤ Safari and tapping Clear History and Website Data.

The reading list can take up some other unnecessary space because Safari keeps an offline reading list. Removing this offline reading list doesn't affect the items in the reading list on your iPhone or other devices. So, it can be a good way to free some more space.

1. Tap General ➤ Storage & iCloud Usage ➤ Storage.

2. Scroll down and tap Safari.

3. Swipe left over the Offline Reading List item, and tap Delete to clear the cache (see Figure 10-5).

4. Tap Website Data, scroll down, and tap Remove All Website Data.

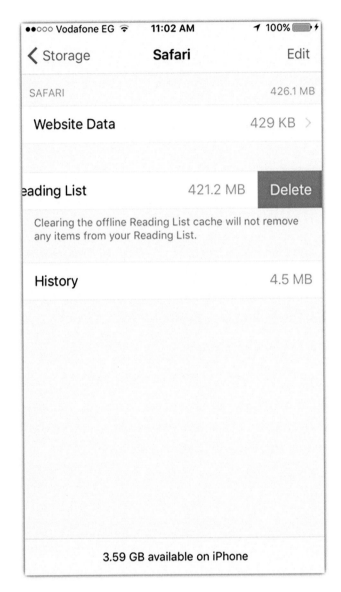

Figure 10-5. *Removing the browser's offline reading list*

Save and Manage Photos Using iCloud

The world is now shifting to cloud solutions and ditching the traditional local storage memory cards and hard drives. Cloud solutions give you flexible storage and reachability because you can access your resources from any device. You can use the iCloud service to store your photos and important documents, which frees up some space on your device. It also allows you to access your resources from your other devices such as an iPad, a Mac computer, or a Windows PC.

Activate Saving Photos to iCloud

When joining iCloud, you get a 5GB free plan to store your information. Obviously, this is not enough space to store files, especially if you are using multiple devices. Therefore, you need to decide which application is able to save files to the iCloud. You can activate saving photos to iCloud, as follows (see Figure 10-6):

1. Tap Settings ➤ Photos & Camera.

2. Swipe next to iCloud Photo Library to toggle it on.

3. Choose Optimize iPhone Storage to automatically manage your photo storage. Instead of keeping the originals on your device, the original photos are saved on iCloud instead.

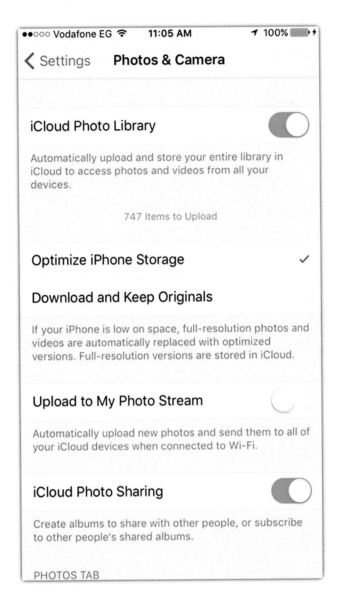

Figure 10-6. *Activate saving the photos to the iCloud service*

Manage iCloud Storage and Apps

You can review your iCloud status directly from your iPhone to see the available space and the applications that are allowed to save documents to iCloud (see Figure 10-7).

1. In the Settings app, tap your Apple ID name, and tap iCloud to view the storage status.

2. Scroll down to review the applications that are allowed to use iCloud.

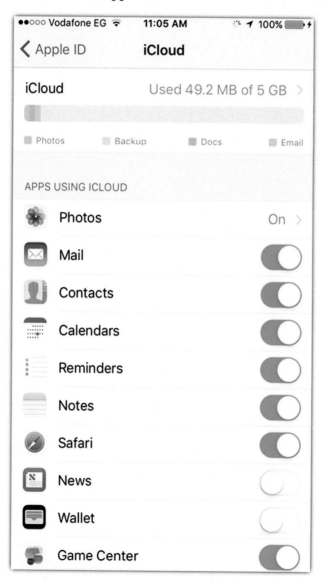

Figure 10-7. *Allow or disallow apps from using iCloud*

If you decided to switch off the sync process between one of the apps and the iCloud, you may notice a message that tells you that the documents associated with this specific app will be removed from iCloud storage.

You can also access iCloud using a web browser to see the different applications in the cloud and access the Photos storage area. Once you activate the iCloud Photo Library from the Photos app settings, you can see the photos uploaded to iCloud and manage them by adding photos, deleting photos, or organizing them into folders (see Figure 10-8). To access iCloud from your browser, you can follow these steps:

1. In your browser, type `www.icloud.com`.

2. Log in using your Apple ID and password.

3. Select photos from the Dashboard.

Figure 10-8. *Managing the iCloud service using a web browser*

On the left side, you can find the different folders that your iPhone uses and navigate to the uploaded photos. From the top right icons, you can upload photos, create new folders, share photos, download photos, or delete them.

Use Other Cloud Services

iCloud is not the only cloud service you can use to store photos and documents from your iPhone. Although the iPhone is highly integrated with iOS, there are other services that you can download and use such as Dropbox, Google Drive, and One Drive. All these services provide a free plan where you can enjoy free storage. For example, Dropbox provides 2GB of free storage before you need to upgrade. If you invite others to use the app, you get extra space as a reward. Google Drive provides the largest free storage space; it gives you 17GB. Additionally, it lets you create documents and photos using different apps such as Google Docs and Google Slides and save them to Google Drive automatically.

If you are not sure if the iCloud free space could save all your photos, you can use any of the other cloud services to save your photos by simply uploading photos to the cloud using these apps (see Figure 10-9). Dropbox gives you the ability to upload your camera photos to its storage, as follows:

1. Open the Dropbox app, and log in with your username and password.

2. Tap the top-left Settings icon.

3. Tap Camera Uploads and swipe the toggle to On. This will upload the photos to the Camera Uploads folder on Dropbox.

4. Toggle the Upload Video item to upload the videos in the same folder.

5. Make sure that Use Cellular Data is off to allow you to upload through a Wi-Fi connection only.

6. Toggle Background Uploading to On and then choose Enable. This will let Dropbox upload photos when you move from one place to another.

Figure 10-9. *Using Dropbox to save camera photos*

Sync Raw Files Using the Lightroom App

You may notice that the photos taken or modified inside the Adobe Lightroom app are saved by default in a separate location other than the Camera Roll, with the ability to share the images with the Camera Roll. These saved photos preserve the editing applied to them inside the Lightroom app so you can open them again and modify or change the effects applied. You can also take Raw photos using the Lightroom app if you want unprocessed photos that can give you a lot editing capabilities. However, saving the Raw file and the file modifications can consume a huge portion of your iPhone space due to the large file size of these photos.

Adobe Lightroom provides cloud storage for Adobe Creative Cloud members; you can save photos from both your desktop and mobile applications to the Adobe cloud services. The free subscription gives you 2GB of free storage, while the paid membership gives you 20GB of storage. You can activate the Adobe Creative Cloud in your Adobe Lightroom app by simply logging into your account from the app. It will automatically upload the photos in the Lightroom library and update the modifications applied to any of the photos.

You can sync the photos from the Lightroom app library and the Adobe cloud service as follows (see Figure 10-10):

1. Open the Lightroom app on your iPhone.

2. Tap the Cloud icon on the top left, and sign in with your Adobe ID and password.

3. Tap the icon to sync the photos with the online storage.

Figure 10-10. *Syncing between the Lightroom app and Adobe cloud service*

You can also manage the photos on the online cloud storage through your browser as follows (see Figure 10-11):

1. In your browser, go to `https://lightroom.adobe.com/`.

2. Log in with your Adobe ID and password.

3. Click the Add Photos icon to add photos from your computer to the cloud.

4. Click the Select icon on the photo to delete, share, or change the location.

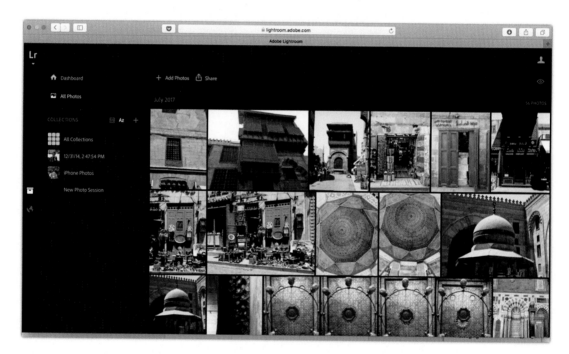

Figure 10-11. *Accessing the Lightroom cloud storage using the computer browser*

Sync Files with Your Computer

Many people love a big screen; I know it helps me to see the details of a photo and pick out the little issues that need to be fixed. You can sync photos from your iPhone to your computer to modify, store, or share with others. Also, you can sync between your Photos folder on your computer and your iPhone to be able to have a copy of your photos and special memories on your phone.

Import iPhone Photos to Your Computer

You can easily import iPhone photos to your computer using the Photos app on a Mac and a USB cable to connect your device to the computer. Once it's connected, you may receive a message to ask you if you trust the computer to connect with your device. Once you accept that setting, you will be able to see the iPhone photos listed in the left navigation pane.

You can import the photos from your iPhone to the Photos app on a Mac computer as follows (see Figure 10-12):

1. Open the Photos app on your Mac computer.

2. Select the iPhone in the left Import pane.

3. Select the photos you want to import.

4. From the top control bar, choose either Import All New Items or Import Selected. You can select Delete Items After Importing to remove the original photos to save space.

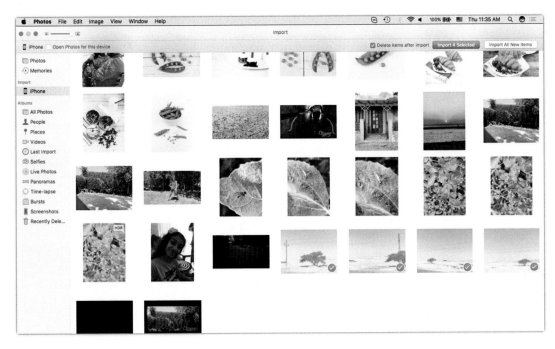

Figure 10-12. *Importing iPhone photos using a Mac's Photos app*

If you are using a Windows PC, you can import the photos by simply plugging in the iPhone to the computer and waiting for the AutoPlay window to open; then choose to import photos. You can also use applications such as AnyTrans.

When you import the photos, they are saved inside the Photos app folder where you can share, adjust, or make them favorites from inside the app. To save the photos in the Finder to be able to open them in photo-editing applications such as Photoshop or Lightroom, you need to export them as follows (see Figure 10-13):

1. Select the photo you need to export.

2. Choose File ➤ Export ➤ Export Photo.

3. In the Export dialog box, choose the export format, color profile, and size; click Export.

4. Save the photo to your local machine.

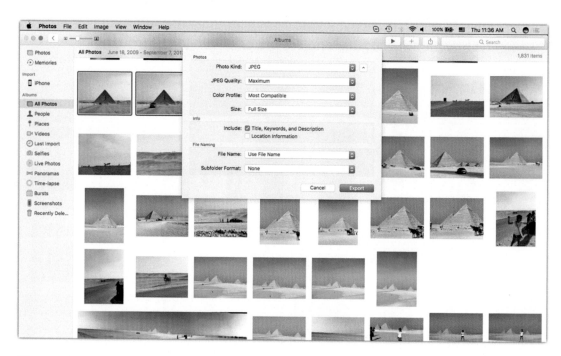

Figure 10-13. *Exporting photos dialog box in the Photos app*

Sync Photos from the Computer to Your iPhone

You can easily sync the photos you have on your computer and your iPhone using the iTunes app, which is available on both Mac and Windows. This can help you sync photos, music, books, apps, and podcasts. To sync the photos, you can follow these steps (see Figure 10-14):

1. Open the iTunes app.

2. Click the iPhone icon at the top left.

3. In the Settings section, click Photos.

4. Select the Sync Photos check box.

5. In "Copy Photos from," select the folder of the photos you would like to sync.

6. Choose to sync either all the folders or selected folder.

7. Click Apply at the bottom right.

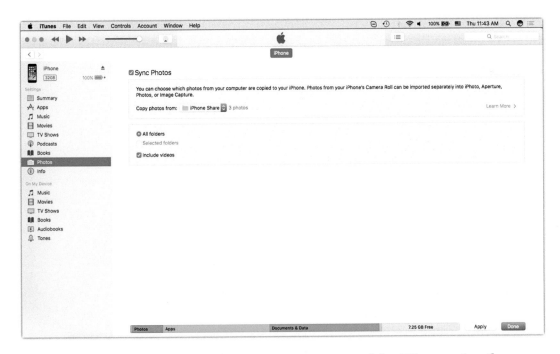

Figure 10-14. *Syncing photos from your computer and the iPhone using the iTunes app*

Summary

While the iPhone storage space may not help you to save an endless number of photos and projects, cloud technology helps you overcome this barrier by giving you the chance to save photos in different cloud services such as iCloud, Dropbox, Google Drive, One Drive, and Adobe Cloud. You can use these services to efficiently manage the space on your device to make sure you are not out of space when taking the next shot. You can either use the free version of different applications to get a small amount of storage space or subscribe to one service to get enough storage for all your projects. You can also save photos on your computer by importing them using the Photos app on a Mac or applications such as AnyTrans on Windows.

Practice Exercise

Use the techniques in this chapter to reduce the consumed storage space on your device. Download one or more of the cloud service applications and use it to save your photos. Notice how much space you can free up on your device.

CHAPTER 11

Photo Editing for Social Networks

Social networks play an essential part not only in your own Internet social life but in the photography profession. Many photographers depend on their social profiles on Facebook, Instagram, 500px, Pinterest, and other platforms to present and promote their work. This helps their work get seen by a massive number of visitors to these networks every day. Your iPhone makes it easy to share your work on these networks. All you need is to take the shot, edit it if needed, and upload it directly from any photo-editing app.

Online tools such as Adobe Spark also provide features and tools that can help you edit photos. You can use their tools to create dynamic photo projects and show your work to your clients, as you will explore in this chapter's tips.

Create an Attractive Photo Presentation with Adobe Spark

Tools used: Adobe Spark Page

Adobe Spark is a group of mobile apps that help you create different social content with your photos. Adobe Spark Page helps you create dynamic pages that can include photos, videos, and text, and then you can share them your clients. Spark Video allows you to merge a number of videos and add text transitions between them. The Smart Post feature lets you edit photos and add text to them to create eye-catching social posts.

The photos and text you create with Spark Page can be accessed either through a desktop computer or mobile device. In the following steps, I will show how to create a Spark page for my trip to Paris. Follow along with your own photos.

309

© Rafiq Elmansy 2018
R. Elmansy, *Developing Professional iPhone Photography*, https://doi.org/10.1007/978-1-4842-3186-9_11

Step 1: Create the Page Layout

To create the page layout, follow these steps:

1. Open the Spark Page app. You can review the Inspiration
 examples to see different layout examples (see Figure 11-1).

Figure 11-1. *The Inspiration examples in Adobe Spark Page*

2. Tap the plus icon.

3. Tap "Add title and subtitle" and enter your title (see Figure 11-2).

Figure 11-2. *Adding a text and subtitle to the page*

4. Tap the image icon to add a photo background for the title.

5. Scroll down to display the menu, and tap the Text tool to add a paragraph of text about the photo project (see Figure 11-3).

Figure 11-3. *Adding the background image and paragraph text*

6. Tap the plus icon under the text to add more content, and select Photo Grid to display a number of photos in a grid.

7. Select the photos to add to the grid and tap Add.

8. Tap the plus icon next to the grid and add a description text (see Figure 11-4).

Figure 11-4. Adding a photo grid to the Spark page

9. Repeat the previous steps to add more images to the project.

10. In the top icons, tap the Effects icon to change the fonts on the page. Select the Chic font (see Figure 11-5).

Figure 11-5. *Changing the page font*

Step 2: Preview and Share the Page

To preview and share the page, follow these steps:

1. Tap the Preview icon at the top right of the screen to preview the created page.

2. Tap the Share icon and complete the page information such as the category and copyright.

3. Swipe the Get Noticed option to make the page available on Adobe Spark Page.

4. Use the Share icons to share the page.

5. Tap "Create public link" to create a link that anyone can see for the page (see Figure 11-6).

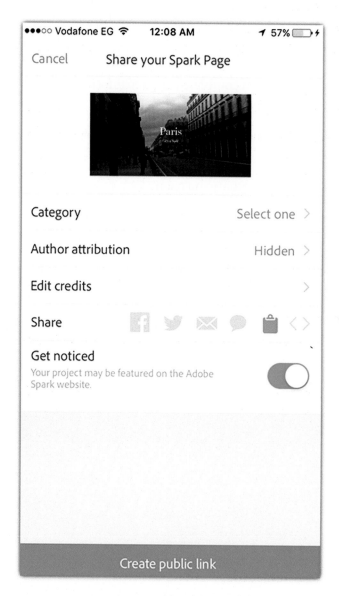

Figure 11-6. *Creating a public link for the Spark page*

Create Instagram Grid Photos

Tools used: Pic Splitter, Moldiv

If you're a photography buff, you've probably used Instagram. You can use Instagram to split a photo into multiple parts and post them on Instagram in a grid or as separate posts.

You can use the grid feature to split panorama photos so that they fit onto some social networks that have limitations on the viewable size of photos. For example, uploading a panorama photo (nonsquare size) to Instagram may affect how the photo is viewed. In the following example, I will use a photo of a street in Paris; I will show how to split it into multiple photos, apply a filter to them, and post them to Instagram as a grid of posts.

Step 1: Split a Photo into Multiple Parts

To split a photo into multiple parts, follow these steps:

1. Open the Pic Splitter app.

2. Tap the Load Image icon in the top bar, and select an image from the Camera Roll.

3. At the bottom, select the first grid, which splits the photos into nine parts (see Figure 11-7).

4. Tap Save Tiles to save the images to the Camera Roll.

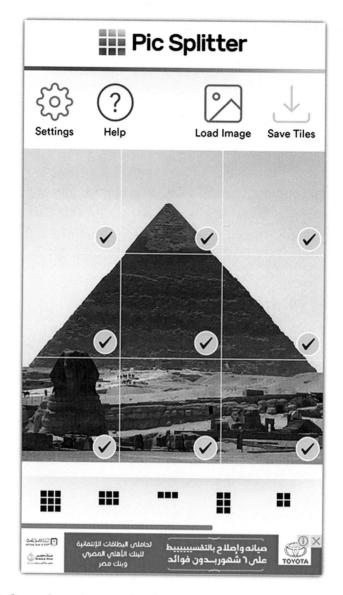

Figure 11-7. *Split a photo into multiple parts using the Pic Splitter app*

Step 2: Add Filters to the Split Photos

To add filters to the split photos, follow these steps:

1. Open the Moldiv app.

2. Open the first photo and choose Filters.

3. From the Basics list, choose Brooklyn and drag the slider to the far right to increase the filter effect.

4. Apply the filter to the rest of the photos in the grid (see Figure 11-8).

5. Tap the Share icon to save the document to the Camera Roll.

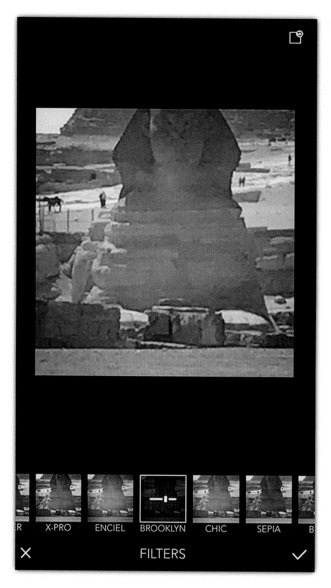

Figure 11-8. *Apply a filter to the split photos*

Step 3: Share the Photos

To share the photos, follow these steps:

1. Open Instagram and start by posting the photos starting from the bottom left to the top right to fit with the layout of the Instagram profile. So, the photos will be displayed in the form of a grid (see Figure 11-9).

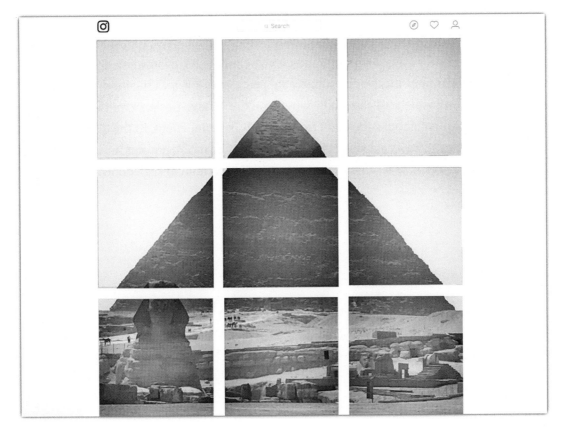

Figure 11-9. *The grid posts in Instagram*

Turn Photos into Social Branding Images

Building powerful social profiles requires an attractive look for your pages or portfolios. As you take photos and modify them using your iPhone, you'll want to manage the layout of your different social profiles and display your photos on them in attractive ways. However, it is hard to manage the different standard sizes related to each profile such as the banner image size. A handy app that can help you take your photos to another level is Canva.

Canva is a web-based photo-editing and template creator application with a mobile app that you can use on your iPhone to access all the web features. Canva allows you to create and edit photos for use on different social networks for promotion and branding purposes. For example, you can use it to create posts, posters, and business cards using your photos. Canva is helpful especially when you don't have design experience to set up the size of the banner, choose the right font, or add a special effect. In the following steps, I will use Canva app to convert one of my photos to a Facebook banner for my page. Then, I will use it to create a business card that can be printed and given to clients.

Step 1: Create a Facebook Banner

To create a Facebook banner, follow these steps:

1. Open Canva app and choose Facebook Cover from the top menu.

2. Select one of the styles that you like to customize. For example, I will use the first template (see Figure 11-10).

Figure 11-10. *Using the Canva Facebook Cover templates*

3. Tap the background photo. You will notice that the Camera Roll
 appears on the bottom. Select one of the photos.

4. Drag the photo with one finger to reposition it, and use two fingers
 to scale it (see Figure 11-11).

Figure 11-11. *Modify the photo size and position of the banner*

5. Tap the Filters icon to choose a filter and apply to the image. I will choose the Guyfe filter.

6. Double-tap the text to start editing the text and type your own desired sentence. Then, tap Done.

7. Use the text tools to change the text font, size, color, and spacing (see Figure 11-12).

Figure 11-12. *Adding and modifying the text for the banner*

8. Tap the plus icon to display the shapes, choose one of the separators, and place it between the main text and the text under it (see Figure 11-13).

9. Tap the Share button to save the image and use it to update your Facebook page or profile banner.

Figure 11-13. *Adding a separator shape on the banner*

Step 2: Create a Photography Business Card

To create a business card, follow these steps:

1. Open the Canva app and choose Business Card.

2. Select one of the templates that will suit your photography business. I will choose a simple one with some background text (see Figure 11-14).

Figure 11-14. *Use the Business Card template to create your own customized card*

3. Repeat the steps you used to create the Facebook banner to
 modify your business card (see Figure 11-15).

Figure 11-15. *Modifying the layout of the business card*

4. Tap the Share icon. You can choose between different print-friendly formats such as a PNG image, standard PDF, or print-friendly PDF (see Figure 11-16).

Figure 11-16. *Saving the business card in a print-friendly format*

Summary

Not only does your iPhone allow you to take great shots, but it also helps you share them through different social networks. You can even use apps on your iPhone to integrate your photos with the different social networks you are on. For example, you can use the Instagram layout to display photos on a grid view, display your photos in a presentation mode using Spark Pages, or turn them into a creative Facebook banner for your Facebook page. The tips in this chapter covered different apps that can help you integrate your photos with social network profiles.

Practice Exercise

Start by selecting a project that includes a number of photos for a specific theme or location. Then, build a presentation with a description. You can use Spark Page to create this presentation and share it with your friends. Then, select one of the photos and share it on Instagram using a grid. Also, you can use this image to create a Facebook banner or a business card.

Marketing and Selling Photos Like a Pro

Mastering the artistic and technical sides of iPhone photography is clearly not enough to build a professional photography business that can return profits and accolades. While there are numerous talented iPhone photographers, few are able to turn their talent into a professional career. To do so, you must understand the marketing and business sides of the job, including how to market your social profile and make it visible for the world to see. With today's technology and social networks, it is easier than ever to do this.

There are apps for your iPhone that extend your capabilities on the business side; they will help you to manage the paperwork associated with your projects such as contacts, forms, and model releases. You can also use your iPhone to give feedback, comment on documents, sign forms, and send contracts.

Managing Contracts and Forms

Tool used: Adobe Acrobat mobile

Adobe Acrobat is one of the most powerful tools in document management on a desktop. The mobile version includes many of the desktop version features that can help you to easily manage your documents related to photography projects, such as model releases and contracts. You can scan documents, add comments to them, sign them, and share them with your team.

Scanning Documents

One of the recently added features to the Acrobat mobile app (see Figure 12-1) is the ability to scan a paper document and modify it to enhance the scanned version of the document. Once you are done, you can edit it, share it, and save it to the Adobe Cloud service.

331

© Rafiq Elmansy 2018
R. Elmansy, *Developing Professional iPhone Photography*, https://doi.org/10.1007/978-1-4842-3186-9_12

Figure 12-1. *Adobe Acrobat mobile app main interface*

While Acrobat allows you to use the flash on your camera and set it to either on, off, or auto by clicking the flash icon on the bottom left of the screen, it is advised to scan your document in good light conditions such as with ample daylight. This will ensure a

clear and good-quality scanned image. Additionally, try to avoid any shadows that may appear when you hold the camera in your hand; you can try changing your position or the position of the scanned image.

Step 1: Set Up the Document and Scan

To set up the document and scan it, follow these steps:

1. Open Adobe Acrobat.

2. Tap Acrobat's left menu icon and choose Scan (see Figure 12-2).

Figure 12-2. Acrobat app's left menu

When you scan a document, Acrobat allows you to crop the scanned photo to display only the required area. To make sure that Auto Crop is on, tap the right-bottom icon.

3. Point your camera to the document's first page. Acrobat detects the page by displaying a blue rectangle around it. Once you are satisfied with the results, press the Camera button to take the shot (see Figure 12-3).

Figure 12-3. The Acrobat Scan feature detects the paper borders and highlights the detected area in blue

Step 2: Add and Modify the Scanned Document

To add and modify the scanned document, follow these steps:

1. On the Review screen, you will find the scanned photo. You can add more photos by clicking the Add Photo icon, whether you can choose Take Another Photo or Select from Photos.

2. Tap the Reorder icon to rearrange the pages' order in the document by simply dragging a photo into the preferred order (see Figure 12-4).

Figure 12-4. *Drag the pages to reorder them*

3. Click the Crop tool to modify the cropping area. Use the rectangle
 to define the area to crop and click Done. You can click the Rotate
 icons to change the rotation of the page.

4. You may notice that the colors on the page are not the same as the
 original document. You can determine the color type for the image
 by tapping the Color Edit icon, which allows you to choose between
 Original Photo, Auto Color, Grayscale, and Whiteboard (see Figure 12-5).

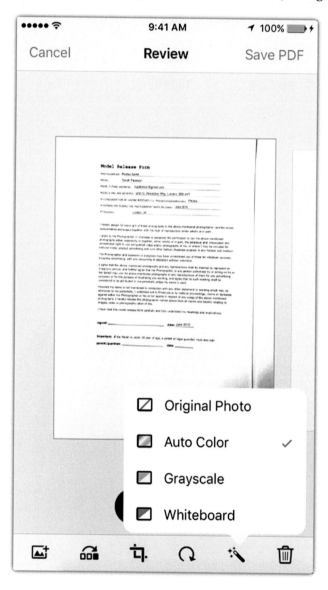

Figure 12-5. *Choose the color setting for the final document*

Step 3: Share Documents

You can save a document and share it with others by tapping the Save PDF button at the top right of the screen. You will need to add the name of the document. If you have a free Adobe Document Cloud membership, the document will automatically be saved to the cloud. You can also tap Save to Cloud to save it manually. You can tap Share to send the document to people through e-mail, Skype, WhatsApp, and other applications. When you tap the Share icon, you will get the choice to share a link to the document, share the document itself, save it to Adobe Document Cloud, save it to Dropbox, or open it in other applications. You can also print the document if you have a supported printer (see Figure 12-6).

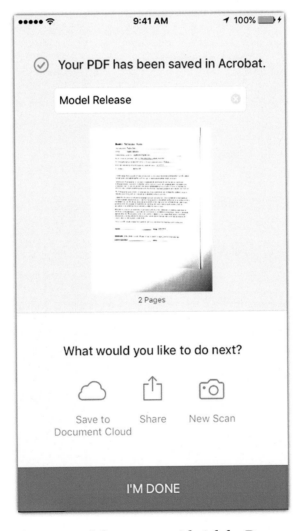

Figure 12-6. *Share the scanned document with Adobe Document Cloud or other applications*

Step 4: Comment on Documents

When someone sends you a document such as an invoice or contract to review, you can use Acrobat on your iPhone to add your comments and feedback before a final signature. You can also send it back for modifications.

1. Tap the Comments icon in the bottom toolbar to activate the comments mode. You can also access the comments mode by clicking Comment in the left menu of Acrobat (see Figure 12-7).

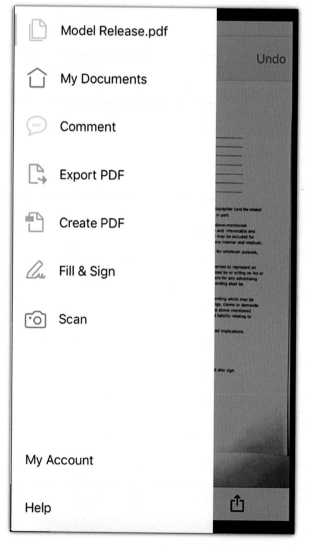

Figure 12-7. *Choose the Comment mode in the Acrobat menu*

2. Click the Note icon on the bottom toolbar. Click the point where
 you want to add a comment on it. In the pop-up dialog box, type
 your name and then type your note. You can also use other tools
 to highlight text, add strikethrough, underline text, add text, free
 draw, and add a signature (see Figure 12-8).

Figure 12-8. *Use the comments tools to add notes, highlight text, and add text*

3. Click Save at the top-right side of the screen. Once the app closes, you can click and drag the note to any part of the page.

Step 5: Fill in and Sign a Document

Tool used: Adobe Fill and Sign

If you have a contract, a form, or an invoice to fill in and sign, Adobe provides a free application, Adobe Fill and Sign, that allows you to do this directly from your iPhone. Adobe Fill and Forms saves you time by keeping a record of the basic information that you frequently use to fill in forms such as your name, address, e-mail, telephone, and more. Also, it stores your digital signature and initials to easily and quickly fill in forms.

Step 6: Fill in Your Profile

To fill in your profile, follow these steps:

1. Open the Fill and Sign app.

2. Click the Profile icon in the bottom toolbar, and fill in your personal information that you may use in forms such as your name, address, e-mail, and so on (see Figure 12-9).

Close	**My Profile**	Settings

Name

Full Name Rafiq Refaat Elmansy

First Name Rafiq

Middle Name Refaat

Last Name Elmansy

Name

Address

Street 1 New Cairo

Street 2 Add Street 2

City Cairo

State Add State

Zip 11777

Country Egypt

Contact Information

Email Elmansy@gmail.com

Tel 01002343234

➕ *Add custom field*

Figure 12-9. *Fill in the profile information in the Fill & Sign app*

Step 7: Add Your Signature and Initials

To add your signature and initials, follow these steps:

1. Tap the Signature icon and choose to add either a signature or
 your initials. The window allows you to draw your signature with
 your finger or using a stylus pen. I suggest using a stylus pen if you
 can't create an accurate one with your finger (see Figure 12-10).

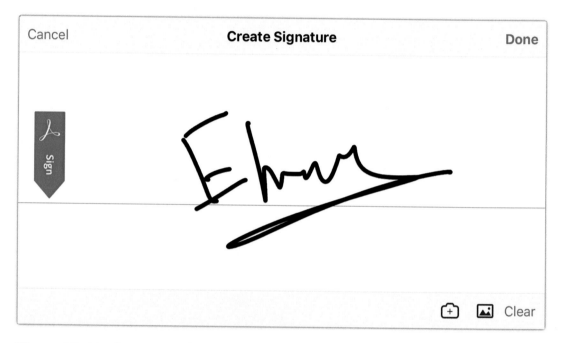

Figure 12-10. *Creating a digital signature using the Fill & Sign app*

2. You can also click the Camera icon on the bottom right to take a
 photo of your hard-copy signature and use it. If you already have a
 signature image, you can click the image icon to navigate to your
 Camera Roll and use that signature image.

Step 8: Fill in Forms

To fill in forms, follow these steps:

1. After setting up your profile information and signature, you can start filling in forms. Click the field you want to fill in, such as the name. A text field appears to let you fill the form by typing the information (see Figure 12-11).

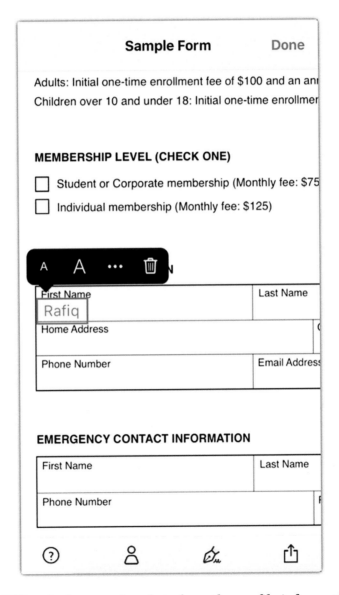

Figure 12-11. *Filling in forms using data from the profile information*

2. If the information is already saved in your profile, click the Profile icon and click the piece of information you want to insert to find it added to the form.

3. If the text is longer than the form field, you can click the added text to display the resizing rectangle that allows you to click and drag to reposition the text or drag the edges to resize the text.

4. At the end of the form, you can apply the same steps as earlier. Click the Signature icon to choose to add either a full signature or just your initials; once you've done that, you can reposition or resize what you added (see Figure 12-12).

Figure 12-12. *Adding a signature from the saved digital signatures*

Build a Photography Portfolio

As a photographer, your profile is crucial to show your work to your clients and followers, get feedback, and engage with the photographer community. If you want to be a professional photographer, your portfolio and your résumé ensure that your client can learn more about your experience and talent.

There are various ways to create your online presence such as personal web sites, portfolio web sites, and social network pages. Each of these types has its pros and cons.

Personal Photography Web Site

Having your own web site with your own URL gives you a professional look and ensures followers and clients see you as an established business. However, it requires a lot of effort and knowledge to register a domain name, a reliable server to host your web site, and administration time to upload and maintain the web site content. Or, you can pay money to a company to handle this all for you.

Portfolio Web Sites

For beginner photographers who want to focus on their work, hosting their own web site is a time-consuming and expensive choice. Therefore, many photographers use portfolio web sites that allow them to create a free account (sometimes with paid upgrades). These web sites include the following:

- 500px.com

- Behance.net

- 1x.com

- Flickr.com

Some portfolio web sites cater to all art fields such as Behance.net (see Figure 12-13), and others focus on photography such as 500px.com (see Figure 12-14). While these web sites don't allow you to have your own URL and the freedom to design your own web site, they offer numerous advantages. Specifically, portfolio web sites save you lots of effort and cost related to creating a professional web site. All you need to do is to create a free account and start uploading your photos.

Figure 12-13. *Behance is for general-topic online portfolios*

Figure 12-14. *500px is an online profile web site that focuses on photography*

Additionally, many of these portfolio web sites include a social networking feature that allows you to follow other photographers, rate their work, and comment on their activities.

Social Network Pages

Another way to build a portfolio is to use social networking sites such as Facebook, Instagram, and Pinterest. These sites are great for social interaction and promoting your work. However, these sites are not designed to display your work as a true portfolio. Followers see notifications once you upload a new photo, and if they need to see your previous work, they have to scroll through your past posts or go to the Photos section.

Based on this, the portfolio web sites can be a good start for both amateur and professional photographers to build their portfolios. Some portfolio web sites, such as 500px, even have mobile applications so that you can directly upload the photos you take from your iPhone after modifying them. The 500px app allows you to take photos and upload them, and the Raw app allows you to take Raw photos and upload them to a marketplace to sell.

Making Your Photos Searchable

If you have an online presence, through either a portfolio site or a social network, you need to make your photos searchable where people can find them, buy them, or download them. When clients search for a specific photo or a photography service, they type what they need in the search field on Google, Bing, or Yahoo.

Search engines don't see images like we do; they see the *metadata* associated with an image, such as the image title, description, and keywords. When uploading a photo to your portfolio, it is important to add this metadata to increase the chance that your clients can find you while searching for photos to buy or a photographer to hire.

Thankfully, the portfolio web sites allow you to easily insert this information while uploading your photos. In the following steps, I will walk you through uploading a photo from your iPhone to your 500px.com profile using the 500px app:

1. Open the 500px app on your iPhone.

2. Tap the Camera icon on the bottom toolbar. This will allow you either to take a photo or to select a photo from your device.

3. Tap the Camera Roll to access your photo album and select the photo that you want to upload to your profile (see Figure 12-15).

Figure 12-15. *Capture a photo or choose one from your Camera Roll to upload to your 500px profile*

4. In the description field, type descriptive information about your photo, such as what it is, its category, its location, and other photography specifications.

5. In the Category section, you can select the category of your photo.

6. In the keywords section, you will notice that the app has added keywords based on the photo content; you can add more keywords or remove the nonsuitable keywords (see Figure 12-16).

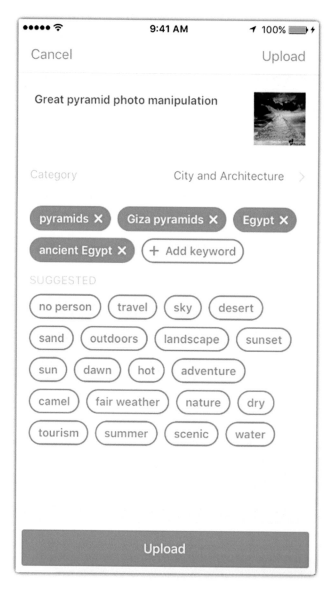

Figure 12-16. *Add the photo description, category, and keywords before uploading it*

7. Click Upload.

8. Once your photo is uploaded, you can share it with your followers on different social networks.

If you used any of the Adobe apps to modify your photo, you can directly upload it to your Behance.net account from in that app, as follows:

1. Open one of the projects you created previously in this book in the Photoshop Mix app.

2. Click the Share icon at the top right of the screen and choose Behance (Figure 12-17).

Figure 12-17. *In Photoshop Mix, choose Behance from the Share menu*

3. Tap the Text icon in the bottom toolbar to add a description for the
 photo, and tap Save. You can tap the Reorder link to change the
 order of the text and image. Once done, click Next (see Figure 12-18).

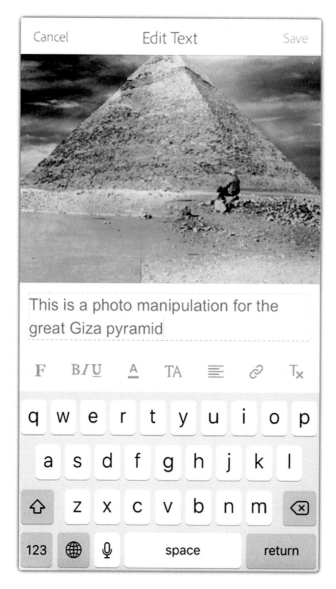

Figure 12-18. Use the Text icon to add text to your project

4. On the Select Cover page, set the cover for your project from the bottom images. Tap Next.

5. On the Info page, fill in the project information (see Figure 12-19).

6. Tap Advanced to add more details about the project.

7. Tap Publish.

Figure 12-19. *Add the project information. Tap Advanced Settings to add more detailed information*

Selling Photos Online

It is time to make some money from your iPhone photos. With the advanced camera features, tools, and techniques you learned, you can make money from your beautiful iPhone photos. Although the photo market is competitive, good photos can make an impact. Before starting to upload your photos to sell, there are some general guidelines that you need to consider to professionally brand your work. These guidelines include the following:

- You need to have a professional profile on the web sites that sell photos. When someone buys your photo, there is a higher chance they will visit your profile or see your other photos. So, it is important to keep it professional. You can easily learn about professional profiles by visiting the top profiles on each web site to see how they look and try to get inspiration from them.

- You need to understand the market demand. What are the photos that people most want to buy? Actually, the answer to this question varies from one web site to another, as you will see later. Therefore, you need to do some research about the most downloaded photos, their themes, and the categories they're in. This can help you to learn which photos to upload to specific platforms. Additionally, many of the current photo-selling web sites give you a higher rate for exclusive photos that you don't upload to other web sites. Accordingly, you can determine which photos are suitable for each web site.

Where to Sell Your Photos?

When it comes to selling your photos, there are different platforms where you can create a photography profile and sell your photos. Usually, they are commission-based platforms, where you get a percentage of each sale. The more sales you achieve, the more percentage you get. This model encourages photographers to promote their photos and upload more photos to increase their sale percentage.

There are many stock photograph web sites, and you can try them all; however, it is probably good to focus on the popular web sites because you will have a better chance to sell your photos there. Sadly, the competition on these web sites is also high. These web sites include the following:

- *Pond 5*: `https://www.pond5.com`

- *Adobe Stock*: `https://stock.adobe.com`

- *Shutter Stock*: `https://www.shutterstock.com`

- *iStockphotos*: `www.istockphoto.com`

- *500px Marketplace*: `https://marketplace.500px.com`

Some of these applications such as Adobe Stock and 500px allow you to submit your photos to their marketplace directly from your iPhone. In Adobe Stock, you can open an Adobe mobile app such as Photoshop Mix and click the Share icon, where you can choose Adobe Stock (see Figure 12-20).

Figure 12-20. *You can upload your photos to the Adobe Stock marketplace from Photoshop Mix*

For 500px, you can download the Raw app, which allows you to take Camera Raw photos directly from your iPhone. After modifying the image, you can choose to submit it to their marketplace.

Also, you can sell your photos on arts-and-crafts web sites such as Easy, which allows you to sell any physical and digital artwork by opening a store. Then you can provide your photos, which customers can either download or print it, or you can deliver them as a printed physical product. While Etsy does not focus exclusively on selling photos, it allows you to provide your photos in both digital and printed formats. This can maximize your revenues.

Finally, you can sell your photos on your own web site if you create an online store on a web site such as Shopify, which maximizes your revenues per photo because there is no commission charged for the stock photo web site. However, you need to heavily market your web site to find clients, which is not an easy job.

Summary

You can take your mobile photography hobby to a new professional level by mastering the business-related tips in this chapter. The new iPhone versions have dramatically improved the camera and photography features, which allows you to take professional photos that you can sell online or add to your professional portfolio. The iPhone also allows you to manage your photography business by giving you access to your documents, where you can review, comment, sign, and share them with your peers. Also, you can upload our photos directly from your phone to your online profile and submit it to marketplaces.

Practice Exercise

The exercise in this chapter is a little different from the previous ones as it doesn't involve any photo editing. Find a paper document or a contract you have in your desk and try to digitalize it by scanning it with the Acrobat app. Then, start using the comment tools to add your notes to the document. In addition, choose a photo from the previously covered projects and upload it to your profile on 500px or Behance directly from your iPhone. Don't forget to add the necessary information to make your work searchable and visible.

APPENDIX A

Photographer Profiles

There are many amazing photographers who work with the iPhone. Get inspired by them in this appendix.

Amo Passicos

`http://melle-amo.fr/`

© Rafiq Elmansy 2018
R. Elmansy, *Developing Professional iPhone Photography*, https://doi.org/10.1007/978-1-4842-3186-9

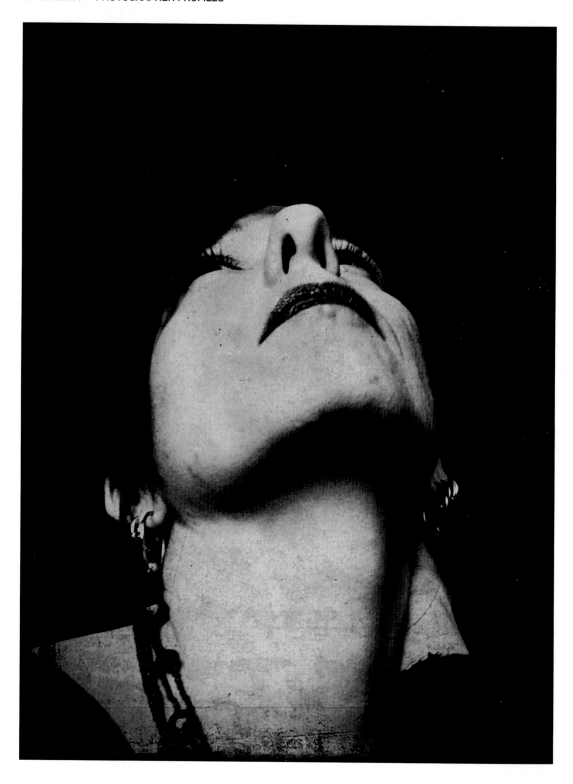

Amo Passicos is self-taught. Even though her pictures might suggest she is short-sighted, chaotic, and family-driven, they simply display the serious disorder of scattered reminiscences she tries to keep before memory escapes her.

Attracted by technological novelty and its spin-off, Amo has peppily tested the hundreds of apps her iPhone offers, with a "first mover" approach. Seduced by the immediacy of images, she shoots her photos by game and with a genuine desire to contribute to the emergence of a new artistic form.

She currently lives in the south of France and manages female rock bands.

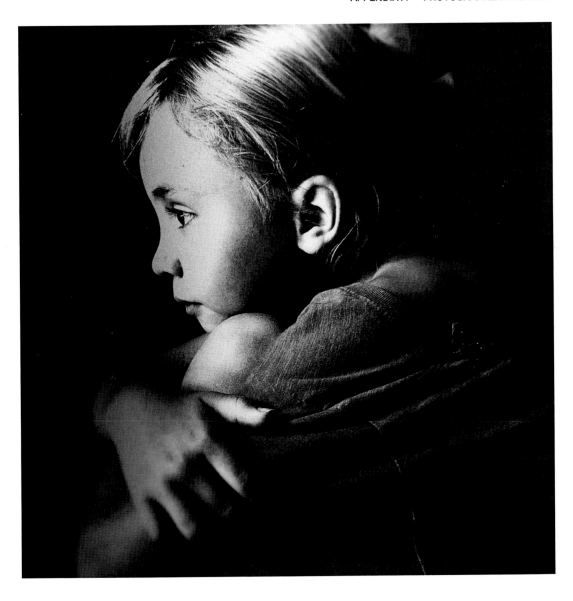

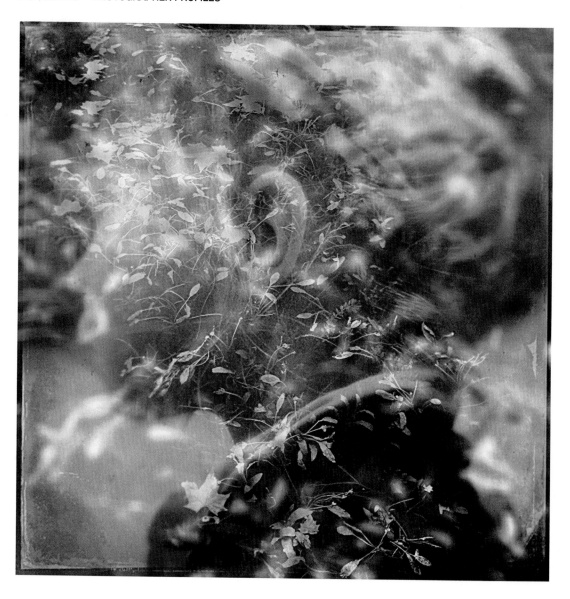

Mandy Blake

www.mandyblakephotography.com

Mandy Blake is a working photographer from Kitchener, Ontario, in Canada. She is an award-winning iPhoneographer who has been featured several times in Apple's "Shot on iPhone" ad campaigns. When she is not chasing light with her iPhone, both above and below the waves, she is a busy wedding and family photographer with a documentary eye and relaxed style.

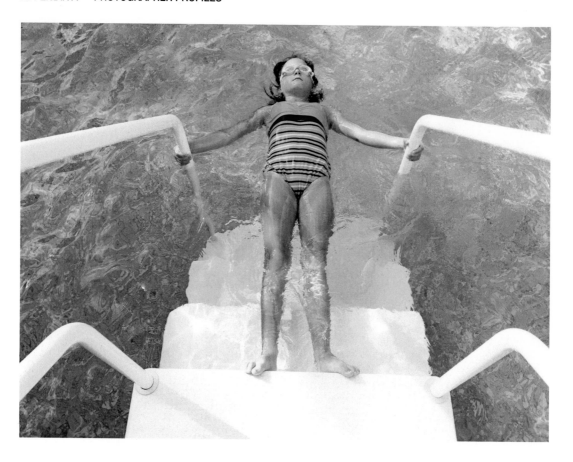

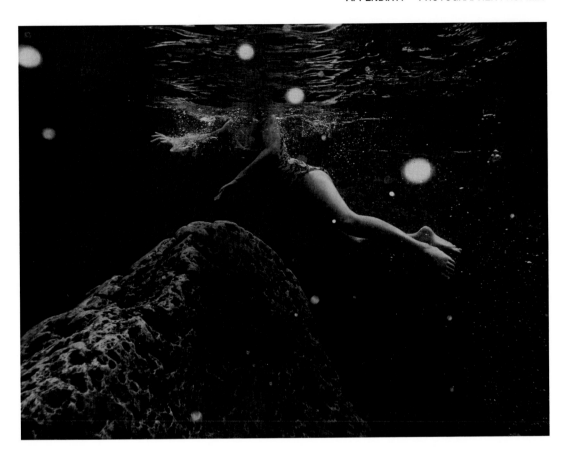

Michael Clawson

Michael Clawson is Chief Fish at Big Fish Creations, an advertising and digital media company in the Sierra town of Graeagle. His background began in Silicon Valley when Apple Computer and Adobe Systems first made their marks in desktop publishing. He was introduced to interactive media early in his career, transitioned to production artist and, later, creator and lead principal of an interactive department at a major Nevada advertising agency. Specializing in branding across multiple media platforms, his diverse repertoire includes a hybrid combination of designer and developer with emphasis on graphic design, branding, photography, and communication. As a speaker, Michael has presented at several industry-specific conferences including Adobe Max and MacWorld.

Michael began communicating as an iPhoneographer in late 2011 when he discovered the power wrapped inside his tiny telephone camera. As a professional photographer, he began to explore the limitations of the iPhone (and thus learned its strengths) and soon began to exploit various facets of his creativity with the device. He credits Instagram as the artistic sharing community where iPhoneography and art have flourished, giving him inspiration toward new opportunities and new discoveries. Michael is also a published author and often writes about and teaches iPhoneography and creative editing.

Index

A

© Rafiq Elmansy 2018
R. Elmansy, *Developing Professional iPhone Photography*, https://doi.org/10.1007/978-1-4842-3186-9

Get the eBook for only $5!

Why limit yourself?

With most of our titles available in both PDF and ePUB format, you can access your content wherever and however you wish—on your PC, phone, tablet, or reader.

Since you've purchased this print book, we are happy to offer you the eBook for just $5.

To learn more, go to http://www.apress.com/companion or contact support@apress.com.

Apress®